WILLIE DOHERTY

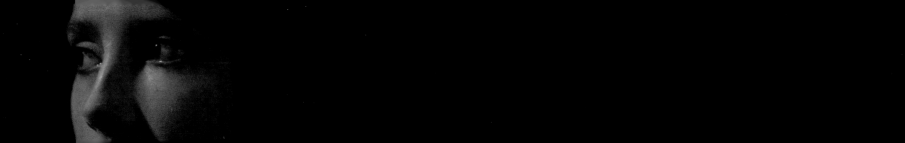

WILLIE DOHERTY
REQUISITE DISTANCE
GHOST STORY AND LANDSCAPE

CHARLES WYLIE
WITH A CONTRIBUTION BY ERIN K. MURPHY

DALLAS MUSEUM OF ART | YALE UNIVERSITY PRESS, NEW HAVEN AND LONDON

This catalogue has been published in conjunction with the exhibition *Willie Doherty: Requisite Distance,* organized by the Dallas Museum of Art, May 23–August 16, 2009, and traveling to the Snite Museum of Art, University of Notre Dame, fall 2010.

Exhibition support is provided by the Contemporary Art Fund through a bequest from the estate of Brooke Aldridge in honor of Cindy and Howard Rachofsky and through the gifts of Arlene and John Dayton, Laura and Walter Elcock, Amy and Vernon Faulconer,

Kenny Goss and George Michael, Nancy and Tim Hanley, Marguerite S. Hoffman, Suzanne and Patrick McGee, Allen and Kelli Questrom, Cindy and Howard Rachofsky, Deedie and Rusty Rose, Gayle and Paul Stoffel, Sharon and Michael Young, and an anonymous donor.

This exhibition is number 53 in the *Concentrations* series, support for which is provided by the Donor Circle membership program through leadership gifts of Gail B. and Dan W. Cook III, Claire Dewar, Nancy and Tim Hanley, Caren Prothro, and Cindy and Howard Rachofsky.

Air transportation provided by American Airlines.

CONTENTS

DIRECTOR'S FOREWORD AND ACKNOWLEDGMENTS BY BONNIE PITMAN 6

CURATOR'S ACKNOWLEDGMENTS BY CHARLES WYLIE 7

PHOTOGRAPHS 10

REQUISITE DISTANCE BY CHARLES WYLIE 33

GHOST STORY 40

WILLIE DOHERTY—A BIOGRAPHY BY ERIN K. MURPHY 93

CHECKLIST OF THE EXHIBITION 95

COPYRIGHT CREDITS 96

DIRECTOR'S FOREWORD AND ACKNOWLEDGMENTS

The Dallas Museum of Art is honored to present this exhibition of works by Willie Doherty, who is one of the most important artists to emerge from Northern Ireland in the past twenty-five years. The exhibition features *Ghost Story,* a grippingly beautiful and suspenseful media installation, and a series of photographs, made in the 1990s. Exhibited together for the first time, these two bodies of work reveal Doherty's skill in capturing the paradoxical idea of Ireland as both an island of beauty and the site of a turbulent history of conflict while expanding his references and meanings to wider ends.

As part of the Dallas Museum of Art's ongoing program *Concentrations,* a series of project-based exhibitions, *Willie Doherty: Requisite Distance* offers our visitors a fascinating look at the way we process still and moving images. In addition, this is only the second American-museum organized, one-person exhibition of the art of Willie Doherty, following that by the Renaissance Society, at the University of Chicago, in 1999.

I would like to gratefully acknowledge Charles Wylie, the Lupe Murchison Curator of Contemporary Art at the Dallas Museum of Art, for his role in the acquisition of *Ghost Story,* for identifying this project and realizing it in collaboration with the artist, and for his insightful essay in this catalogue. He was ably assisted by Erin Murphy, Curatorial Administrative Assistant in the Contemporary Art and Decorative Arts and Design departments, who also provided the informative biographical essay.

The exhibition and catalogue would not have been possible without the generosity of numerous people. We particularly wish to acknowledge the supporters of and the proceeds from the 2007 DMA/amfAR 2×2 for AIDS and Art benefit gala, co-chaired by Jennifer Eagle and Catherine Rose, an event that provided funds enabling the Dallas Museum of Art to acquire *Ghost Story* and, in

so doing, become the only American museum to own it. We are particularly proud of this as *Ghost Story* was a critical success at the 2007 Venice Biennale, where Willie Doherty represented Northern Ireland. Attesting to our longstanding respect for the artist, in 1997 the Museum acquired Doherty's masterful photograph, *The Outskirts,* and we deeply thank an anonymous donor for the funds to do so.

We would also like to acknowledge the support of the Museum's Contemporary Art Initiative. We thank the current donors to this fund, Arlene and John Dayton, Laura and Walter Elcock, Amy and Vernon Faulconer, Kenny Goss and George Michael, Nancy and Tim Hanley, Marguerite S. Hoffman, Suzanne and Patrick McGee, Allen and Kelli Questrom, Cindy and Howard Rachofsky, Deedie and Rusty Rose, Gayle and Paul Stoffel, Sharon and Michael Young, and a donor who wishes to remain anonymous. The late Brooke Aldridge very kindly remembered the Museum's contemporary art program with a generous bequest from her estate made in honor of Cindy and Howard Rachofsky. Appreciatively, we recognize Gail B. and Dan W. Cook III, Claire Dewar, Nancy and Tim Hanley, Caren Prothro, and Cindy and Howard Rachofsky for their support of the *Concentrations* series through their generous leadership gifts, a part of their Donor Circle membership.

To María de Corral, the Hoffman Family Adjunct Senior Curator of Contemporary Art, we offer our thanks for her enthusiasm for and support of the work of Willie Doherty. As one of the directors of the Venice Biennale in 2005, María included a major media installation by Mr. Doherty in her magnificent exhibition. Suzanne Weaver, at the time our Nancy and Tim Hanley Associate Curator of Contemporary Art, and now Curator of Contemporary Art at the Speed Art Museum, Louisville, is also to be thanked for her support of the artist and this project.

At Alexander and Bonin, New York, we sincerely thank Carolyn Alexander and Oliver Newton, who have been crucial to this project from its inception. We are grateful to Sue MacDiarmid for her expert installation of Willie Doherty's work. For the publication of this catalogue, we would like to thank our editor, Frances Bowles; Ed Marquand and Jeff Wincapaw, at Marquand Books, for their ideas and design; and our partners, Patricia Fidler and Carmel Lyons, at Yale University Press.

We extend our thanks to Charles Loving, Director of the Snite Museum of Art at the University of Notre Dame, for his museum's hosting this exhibition in the fall of 2010.

At the Dallas Museum of Art, we very much appreciate Tamara Wootton-Bonner, Director of Exhibitions and Publications, Jennifer Taber, Exhibitions Coordinator, and Eric Zeidler, Publications Coordinator, for their important contributions to this undertaking. Further, we acknowledge the invaluable contributions of Caitlin Overton, Caitlin Topham, and Nico Machida, McDermott Curatorial Interns; Brent Mitchell, Assistant Registrar; and Giselle Castro-Brightenburg, Judy Conner, Gail Davitt, Diane Flowers, Carol Griffin, Jessica Harden, Jim Jenner, Vince Jones, Lance Lander, Anne Lenhart, Kevin Parmer, Chip Sims, Liza Skaggs, Gabriela Truly, Joni Wilson, and Jeff Zilm.

To Willie Doherty, we extend our greatest expression of thanks and appreciation for his intensely meaningful and uncompromising art, proof of the endurance of the creative impulse and a testament to faith in the role that art plays in our collective and personal lives.

Bonnie Pitman
The Eugene McDermott Director
Dallas Museum of Art

CURATOR'S ACKNOWLEDGMENTS

This exhibition and catalogue of the art of Willie Doherty has been a project I have long wished to realize. It has come about as a result of the great dedication of a number of people, many of them already mentioned by Bonnie Pitman. I would like to extend my own thanks to them, and to Jack Lane, my former director, María de Corral, and Suzanne Weaver for their great support. To Erin Murphy, whose assistance has been crucial and cheerful, I give many sincere thanks.

I would like to thank Carolyn Alexander, for her inimitable enthusiastic vigor, and Ted Bonin, of Alexander and Bonin, New York. I wish also to thank Nancy O'Boyle, my fellow Hibernophile in Dallas.

It is gratifying to send this exhibition to the Snite Museum of Art at the University of Notre Dame, my alma mater, whose director, Chuck Loving, asked me to devise a media project for that fine museum. It is an honor to have done so.

Willie Doherty has been exceptional to work with. His art, rising as it does with great integrity out of one of the most seemingly intractable problems of our day, has communicated its power and beauty to international audiences, which speaks of its ability to involve minds and cross borders. Willie's humor and intelligence have been remarkable, and his and his wife Angela's willingness to act as guides and hosts is much and gratefully appreciated. It is a privilege to bring Willie's art to a wider American audience. I would like to dedicate my part in this project to my forebears, Samuel and Bridget Donahue Upton, who wed across sectarian lines in the mid-nineteenth century, and to their descendant William Upton Wylie (Notre Dame, class of 1944) and his wife Cora Ellsworth Wylie, my parents.

Charles Wylie
The Lupe Murchison Curator of Contemporary Art
Dallas Museum of Art

PHOTOGRAPHS

1 INCIDENT, 1993

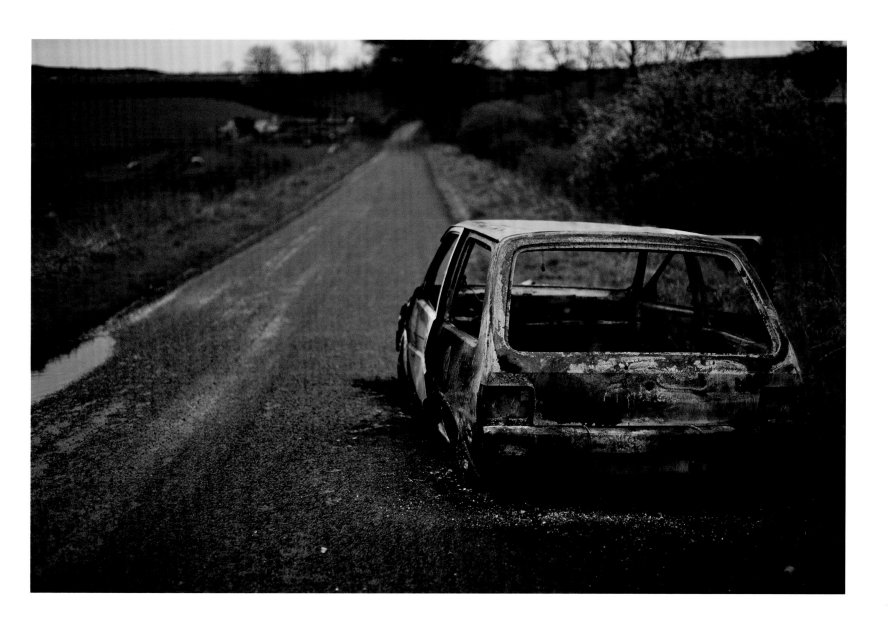

2 THE OUTSKIRTS, 1994

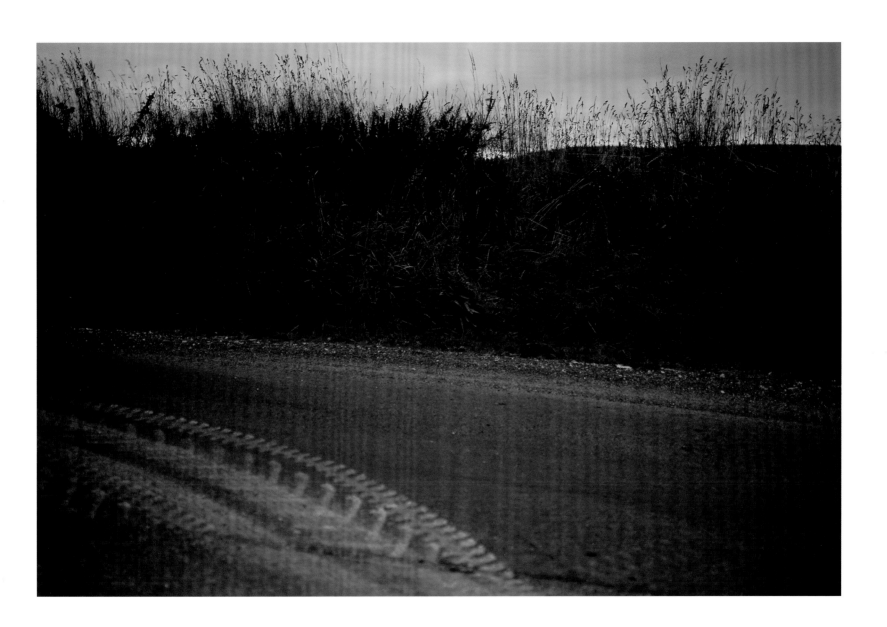

3 BORDER ROAD, 1994

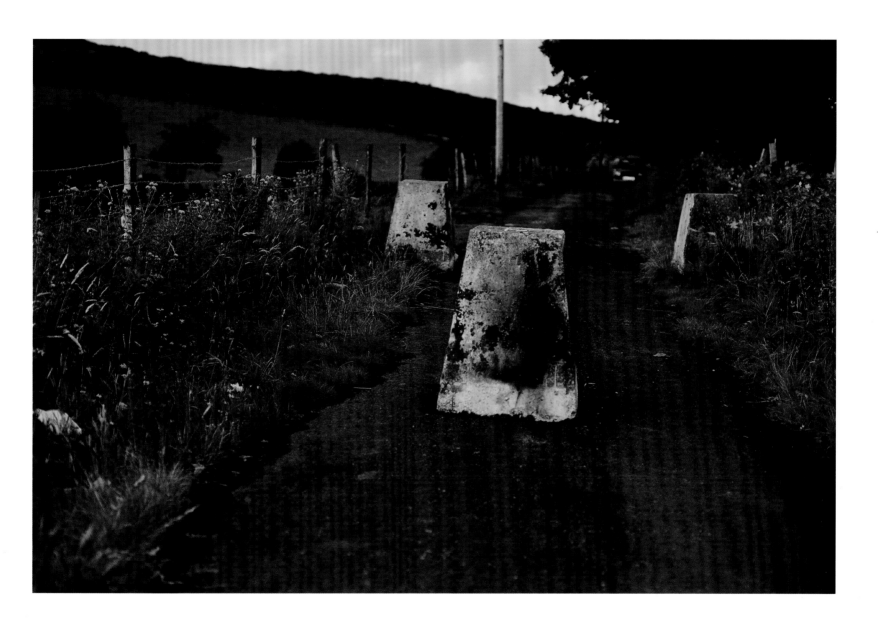

4 AT THE BORDER III (TRYING TO FORGET THE PAST), 1995

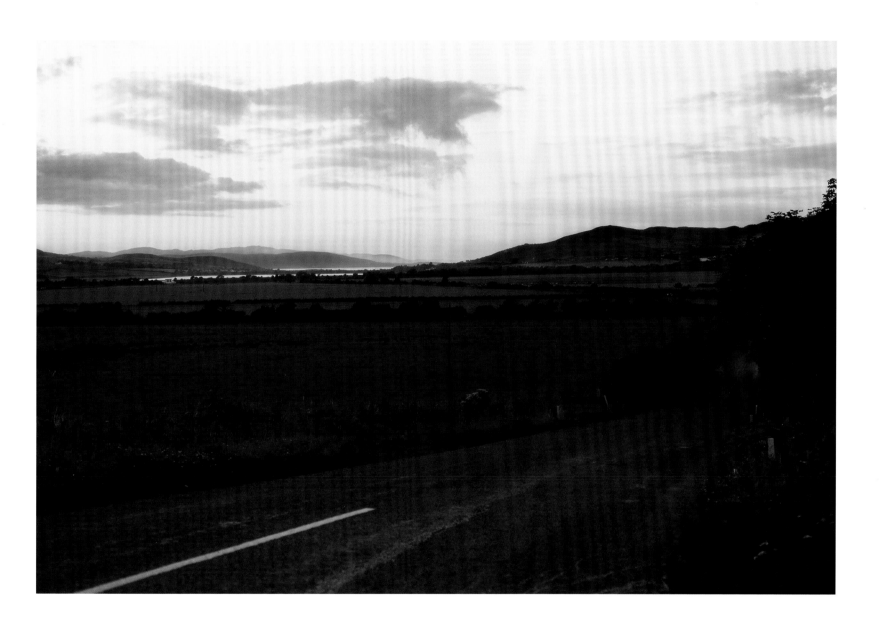

5 UNAPPROVED ROAD II, 1995

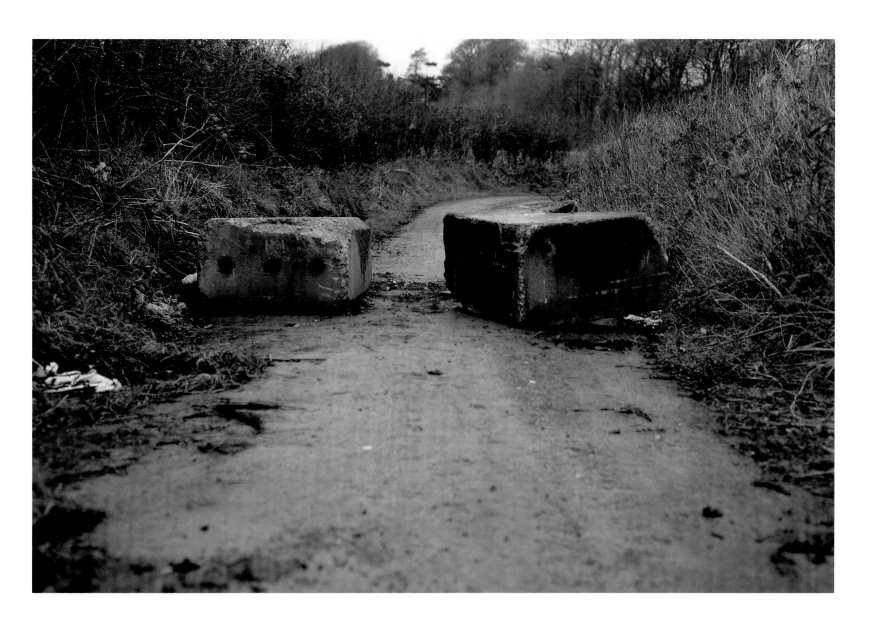

6 AT THE BORDER I (WALKING TOWARDS A MILITARY CHECKPOINT), 1995

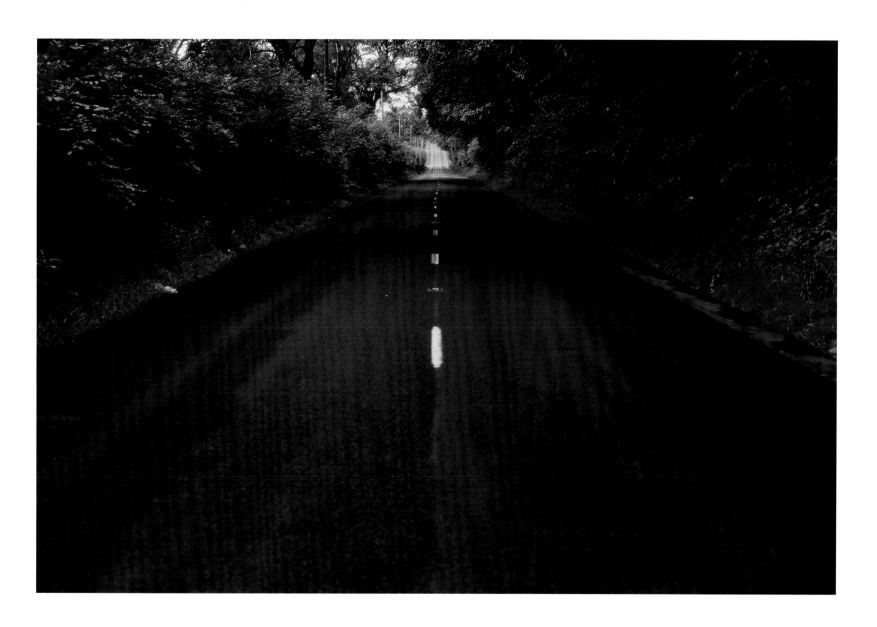

7 AT THE BORDER IV (THE INVISIBLE LINE), 1995

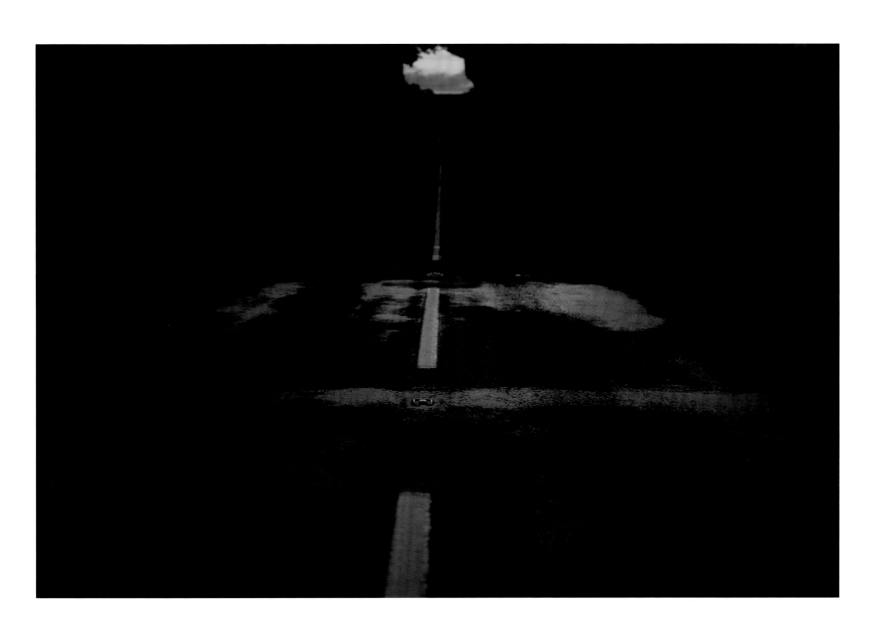

8 THE FENCE, 1996

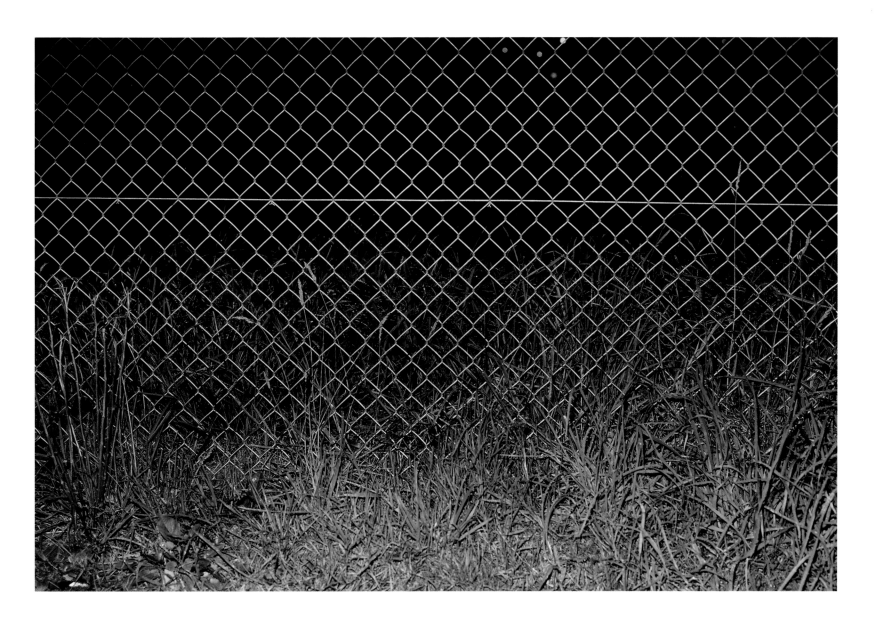

9 NO VISIBLE SIGNS, 1997

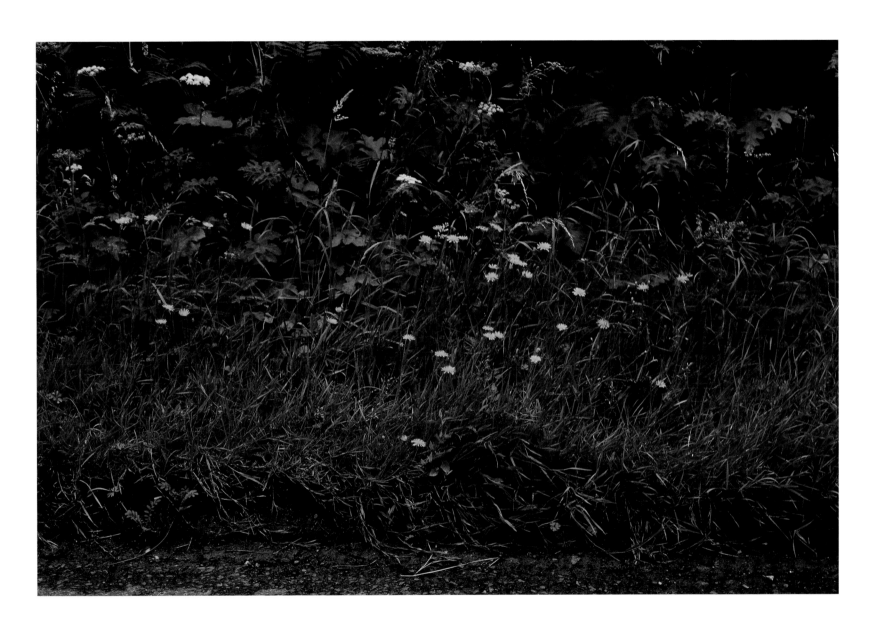

10 BEHIND EVERY TREE, 1999

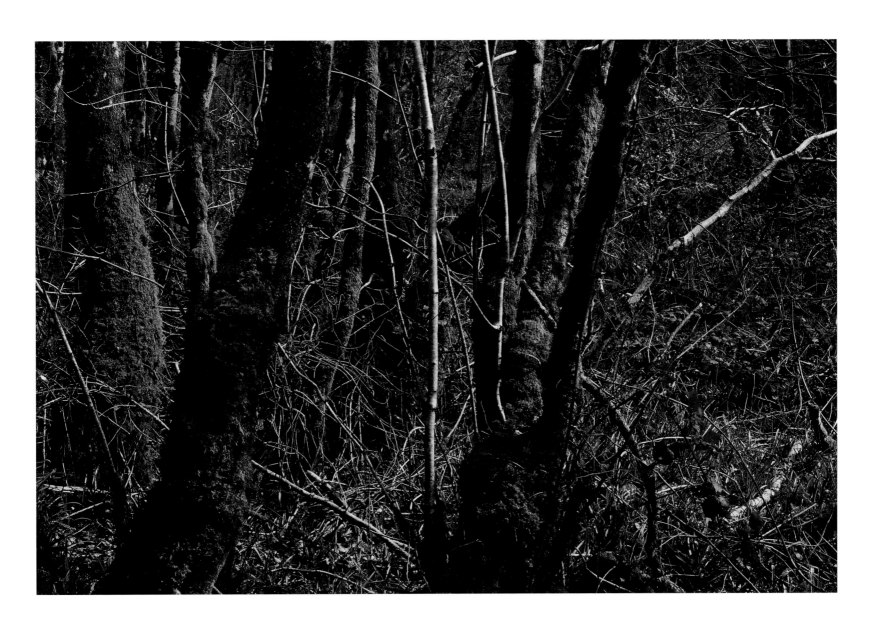

11 THE SIDE OF THE ROAD, 1999

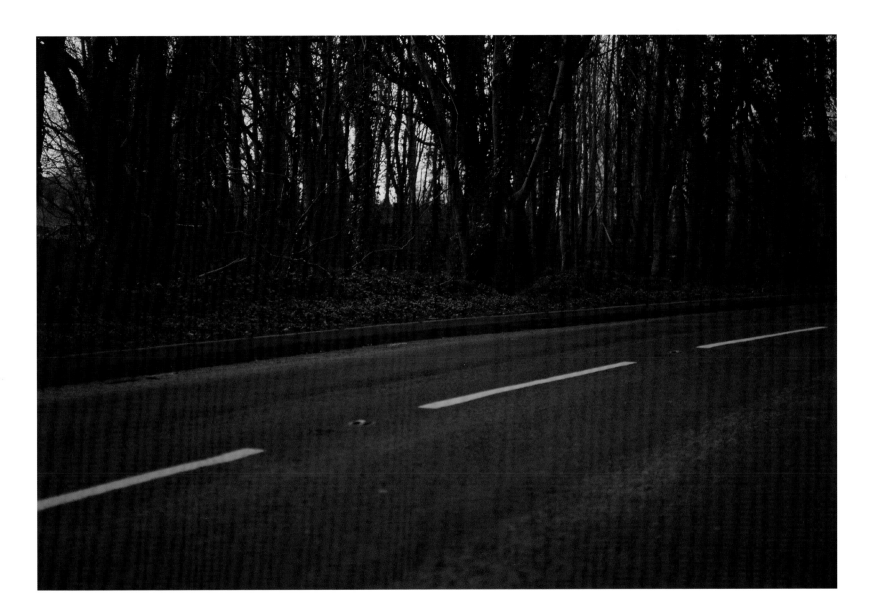

REQUISITE DISTANCE
CHARLES WYLIE

Slowly, one could say stealthily, the art of Willie Doherty enters the eye and mind with a disorienting power and precision. Doherty creates art that is at once unsettling and beautiful, an art shaped by the background of the Troubles in his native Northern Ireland but which communicates across all borders to any receptive viewer. Taking no sides in a highly demarcated face-off, Doherty has unstintingly portrayed through photography and media installations the intense, often crushing psychological and physical effects of that conflict and the part that words and images have played in those effects. Doherty's subjects are those who lived through and succumbed to the Troubles, the land on which the conflict has taken place, and the language and imagery that have been used to define, obscure, influence, and sway. Yet, for all its specificity, his art exists outside the boundaries of determinant historical conditions; it conveys states and places of mind and existence independent of any context save that of being human.

In this exhibition, two types of Doherty's art are presented: a group of eleven photographs, made in the 1990s, and the video installation *Ghost Story*, made in 2007. Both contain the strikingly similar motif of a road, and both find in the land a site of incident and a bearer of meaning. The photographs depict the historically contested, beautiful, yet often disfigured landscape, where the borders of Northern Ireland and the Republic of Ireland meet. Meticulous in their formal composition, featuring dark unvisited roads with monolithic barriers, what look like remnants of crime scenes, and a few, select elements of the storied beauty of the Irish countryside, these large color photographs are purposely hung low and unframed to bring viewers into a closer relationship than conventional images might and to suggest that we experience them as if we were visitors in the country itself rather than visitors in a museum.

Ghost Story presents the same or a similar type of landscape. Here the forms of trees on a riverbank and an unused road act as a unifying visual motif for a series of other sequences: a face from which the eyes are peering back at the past, seeing the future, or witnessing events that we are spared; a series of urban settings in which vaguely menacing incidents unfold but do not reach a resolution. Accompanied by a subtly lyric yet potentially disturbing spoken narrative (written by the artist and performed by the actor Stephen Rea), describing apparitions, premonitions, and memories of trauma, *Ghost Story* provides a measured and tensely mesmerizing cinematic experience suffused with melancholic dread and a spectral beauty.

Springing from the Troubles, these two bodies of work convey some of the states of mind and emotion that such trauma can produce. Both can be experienced on a profoundly deep level, even without any knowledge of the history of the conflict. Thus, in experiencing Doherty's art, one can simultaneously know and not know, a condition at the heart of this artist's formidably intelligent and exacting practice.

One of the challenges of writing about Doherty's art is conveying this sense of opposites, of something that is at once unsettling and beautiful, of something known and unknown, of something not seen but felt. Another challenge is trying to approach the history of the ground from which Doherty's art has arisen, that of the Troubles, with the requisite distance so that, in the service of disinterest and objectivity, one neither overemphasizes nor underplays their impact and does not take sides or even appear to do so. Such hesitancy can overwhelm, however. Language implicates and likely will be misunderstood—one could express something the wrong way and be both true and false in describing a situation from afar.

In light of what has happened in Northern Ireland, silence, then, can seem not unreasonable. These very notions are also there, in parts and at various moments, in Doherty's art, but his art is not silent. The work takes no sides but it *has* come into being and it is there for us to investigate.

The Troubles, which Doherty witnessed (he saw the events of Bloody Sunday on January 30, 1972, in Derry) and which subsided only relatively recently, began in the late 1960s but had their precedents in centuries of political conflict, periods of intermittent violence, and outright warfare between (depending on the histories one consults, and they are legion) English and Irish, Green and Orange, Catholic and Protestant, Ulster and Eire, South and North, Unionist and Republican. There are more of these pairs one could name, but it is worth noting that all of the adversaries are defined by who is on the other side of the "and." Always, they are locked in combat.

In his early work, in the mid-1980s, Doherty made explicit reference to such pairs, focusing on the fierce dominance of binary terms, the sides they engender and represent, and what they exclude. Significantly, it was the similarities of each side's use of language and landscape that Doherty would bring to light for scrutiny. In those photographs, Doherty overlaid text on images of similar urban and pastoral scenes so as to set words and phrases in opposition to one another. The titles of his exhibitions then and since, such as *Same Difference* (Doherty's first media installation), *False Memory,* and *Out of Position,* can stand as an apt shorthand for the comparative strategies of his earliest works.

Doherty's photographs in this exhibition are a selection of those he made in the 1990s. Here he has excised words in favor of focusing on landscape, the objects in the landscape, and the multiple possible meanings to be drawn from them. In these deceptively ordered and deeply rich color photographs, Doherty has registered things that are now (thankfully, one must say) for the most

part vanished. These include concrete roadblocks that echo the forms of ancient monuments, and military checkpoints and borders that are invisible yet ever present in the mind. Light through trees at the end of these roads is far away and seemingly dimming; the tunnel offers not an escape but further obscurity.

In one, a car is at the side of the road, or what was a car. It's half on the road and half on the grass and on the wrong side for this part of the world, but whatever happened to it probably wasn't due to driving on the wrong side. The frame of the car, what is left, has the character of a prehistoric ruin. The metal and paint have been eaten away; shorn off by flame and weather, it would seem. There are no wheels any more, the windows are long gone, shards of glass halo the car, and the door on the right side, the driver's side, stands wrenched ajar. There's nothing approaching on the road ahead; the vanishing point seems to go on for miles. The sky above and in the distance is gray behind the distant trees. This blasted out, wheelless husk of a car has sunk into the ground as if it has found its resting place.

One photograph, an image of a sunset over a distant mountain range, is as close to a vision of unalloyed beauty as Doherty has perhaps ever allowed himself, and it risks the sentimental were it not for the road markings that bring us back to the asphalt. Though of an undeniable beauty, this is not the storied land of the magical and the mythic that we may have imagined. It is the reality of the beauty of the place, a beauty that is incontrovertibly there but one that has been invaded by evidence. It is a paradoxically beautiful world that seems to have accepted its fate as a site for something we don't wish even to think of.

In viewing these works, a low-level anxiety slowly begins to permeate our perception. What looks at first to be stock imagery becomes suspect. What is out here on these roads is not solitary in the anodyne sense; out here, whatever is alone has been abandoned, and its fate is not meant to be seen. It is a world where a

sunset portends something sinister in the coming darkness, where reeds have been trampled because someone went behind them to do something in a place where something happened. The car tracks on the road in front are evidence. The land is witness as well as stage.

Willie Doherty created *Ghost Story* as he did most of the media installations he has made since his first in 1990: he began by filming specific sequences without exactly knowing how they would fall into place. Unusually for an artist working in this genre, Doherty's media practice does not involve his going from point to point, checking off scenes one by one. At the outset he does not know what the final work will look like, nor how it will progress, nor even what scenes it will entail in terms of image and text. Rather, he works as a painter would, or (more aptly, given his background) a sculptor, choosing passages he has filmed and constructing them as an entire work. Only after a set of sequences has been finished can he consider what to include or excise in a final succession of sections that are most often repeated as a single loop.

Ghost Story consists of a number of different scenes unified by the motif of a road by the side of a river, seen, at times, through a phalanx of trees. Moody and mysterious and suggestive of a northern German Romantic painting with an infinite one-point perspective, this road is the place to which the viewer always returns. The sequences of incident—turning a corner in an alley, coming down into an urban underpass, or approaching a car on a strangely surfaced reflective field—raise and sustain the tension level of this nonlinear narrative. Acting as a surrogate is a face and an eye within that face that may represent any number of things: an omniscient viewer or us as viewers; the face of history looking forward or backward; a character perhaps seeing the ghost of the title; or, possibly, none of these at all.

The conventions of the crime scene are invoked here as they are in the photographs. It can indeed seem, when one is going from gallery to gallery in this exhibition, that the still images we see in the photographs have come to life in the film. There is an important difference here, however, and that is the narrated text that acts as a further element in the multifaceted nature of this work. Doherty's early photographs included words printed and basic. In this work, the text is spoken, not seen, and has expanded to a greater length, describing an extraordinary series of images of unease and fear.

Despite its title, Doherty's *Ghost Story* does not overtly correspond to any of the broadly drawn traditions of the macabre, the occult, and the paranormal to be found in film and literature. There might be precedents in the Irish Gothic of J. S. Le Fanu's *Uncle Silas* and especially in Charles Maturin's *Melmoth the Wanderer,* in which the natural and the supernatural are menacingly intertwined amid a particular pastoral gloom. More to the point, and closer to our age, many of the literary and visual images in *Ghost Story* take their cue from the conventions of the contemporary crime story that, in its infinite varieties, forms one of the major genres of popular entertainment.

Crucially, however, Doherty refuses to honor that genre's (perhaps too easy) dependence on the graphic spoken vernacular or even more graphic violence and splatter effects. Doherty's aim is not to pummel his audiences, but to induce a more concentrated state of sustained tension than popular entertainment ever allows. Here, narrative convention does not reach conclusion but is infinitely postponed: we must construct for ourselves what is around that corner, what that figure standing in the underpass will do, who is in the car we as viewers approach. What we think (perhaps dread) will happen provides the content of these sequences as much as anything that we are shown. While images cut back to the road and to the eyes, *Ghost Story*'s narrator tells a tale of wraiths and bodies, of ghosts in the midst of day, and (in one of the more grisly and chilling passages) how a shifting, malevolent liquid

spreads on the ground to existentially destabilize all sense of firm foundation.

In many ways, *Ghost Story* can be seen as Doherty's summation of his media work to date. In its formal terms (its icy sheen overlaying saturated, dense color), sophistication of structure (the return to the road between incident and eyes), and interweaving of image and text (the quality of the latter being especially evocative), it can very well claim to be his major work in the genre of the moving image. It is outstanding for all these qualities as a powerful work of art that suggests how events, especially traumatic ones, are remembered through a scrim of pictures and words dimly illuminated by the faulty subjectivity of memory itself.

The events of the past decades in Northern Ireland are at present being remembered within a radically changed context, that of the cessation of violence. The battleground landscape seen in Doherty's photographs of the 1990s has largely disappeared, but questions now inevitably arise about the proper way to remember what happened there. In other words, what might an authentic ethics of remembrance be, and how intensely does the virulent past propose to lodge in the minds of those looking to the future? *Ghost Story* may be seen to reflect these very things: the fretful apprehension that the events, imagery, and words of the Troubles summon, the hazy uncertainty of memory itself, and the fact that many of those rendered invisible during the Troubles are yet with us in the present.

Ghost Story (the title itself denoting a genre with which we are all familiar) can be seen more generally as a narrative of looking back at something we would rather not see, and of recognizing how utterly lost one can be in the past amid invisible forces beyond one's ken. There is also a seductive quality to each of the scenarios that suggests an entirely different reading, testament to the work's range of associations: the attraction of the unknown, and of the illicit; the suspenseful thrill of being where one should not be and seeing things one should not be seeing, witnessing the edge of an underground existence. Conversely there is depicted the thin edge between doubt and belief and of being made close to mad by sorrow and incomprehension; by seeing and hearing things that may not really be there. Yet, when we return to the road, we are brought back to the trappings of a grounded reality. We can venture forth only so far before we are back where we started and are yet again surrounded by unsettling recollections of a past imperfectly rendered yet still lividly alive.

Willie Doherty's is among the major international bodies of work to emerge in the early 1990s to take advantage of the technical and expressive possibilities of the moving image, adapting the filmic experience to that of the museum gallery. Doherty raises and then confounds our expectations about reportage, narrative, and entertainment, indirectly pointing us to an examination of these conventions and our reliance on them as we attempt to fix (as in ascertain) in our heads what is happening around us; and to distract ourselves (often, ironically, by watching reenactments of those same things we see on the news) with a steady diet of seemingly infinite, and bloody, variations on the crime story. Persistently, his art asks that we not shrink from troubled and maddening situations within a troubled and maddening land, a land of legendary but easily clichéd beauty that can mask its difficult past and its present realities.

It is important, however, to emphasize that there is a way in which to approach Doherty's art without knowing a great deal about the Troubles or Irish history, or that Derry goes by two names, Derry and Londonderry, and the centuries-old reasons for those two names. Most viewers of this exhibition will not be familiar with the details of that history, save for the basic one: in a brutally sectarian divide, two sides have been battling for centuries. This is not to cast aspersions—it is merely to state a strong probability.

If one were to ask almost any group of U.S. citizens about events in Ireland between 1900 and 1940, the years that saw the creation of the Republic of Ireland and Northern Ireland, the two places pictured in Doherty's work, it would be extraordinary to find that many know about the Easter Rising, the War of Independence, and the Civil War, indeed about anything that occurred in the decades before the recent development of economic prosperity that has changed the island forever.

It would be even more extraordinary to find that they know what lies behind the centuries-old events of the Siege of the Walled City, the Battle of the Boyne, the Flight of the Earls, the Ulster Plantations, or the United Irishmen, to list but a few of the more evocatively named chapters of Irish history. All of these are crucial stories, integral to Irish history, but not well known here in the United States, where the image of Ireland is, more often than not, reduced to a sentimentality that neither challenges nor elucidates.

Willie Doherty's art does both. It challenges in its forceful yet elusive depictions of what happened and where (the photographs made in the 1990s), and elucidates in its carefully rendered calibration of what it feels like to remember what happened there, when remembering can be full of pain, imprecision, and residual fear (*Ghost Story* made in 2007). In a body of work that has paid uncommon attention to a specific place (virtually all of his images have been created in and around Derry, in areas covering both Northern Ireland and the Republic of Ireland), Doherty has portrayed, without taking sides, a part of the world known almost before anything else for its dyadic fury, which has parallels in places across the globe and in our minds. This is not because such sides do not exist (no one can yet think this), but because Doherty's art encompasses more and has taken on greater challenges than merely depicting sides. If you see them, they are there; if you don't see them, they are also there.

This essay is based on conversations with the artist that have taken place at various times in recent years and, in particular, in and around Derry in September 2008.

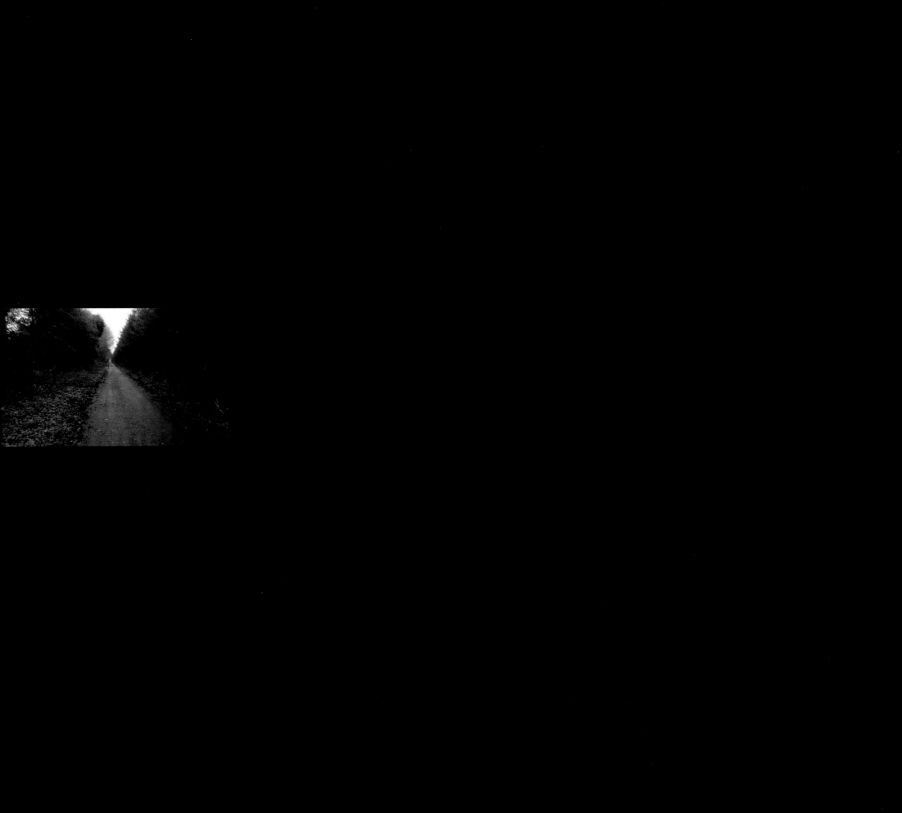

GHOST STORY

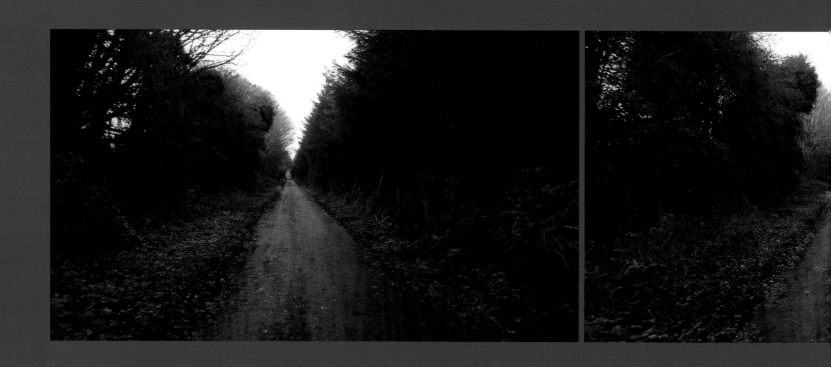

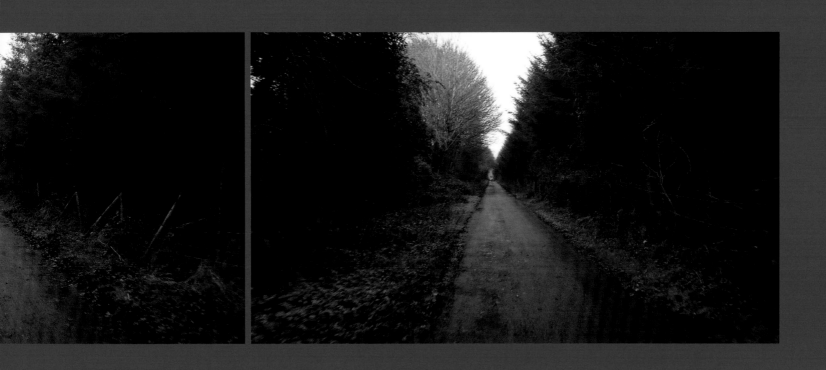

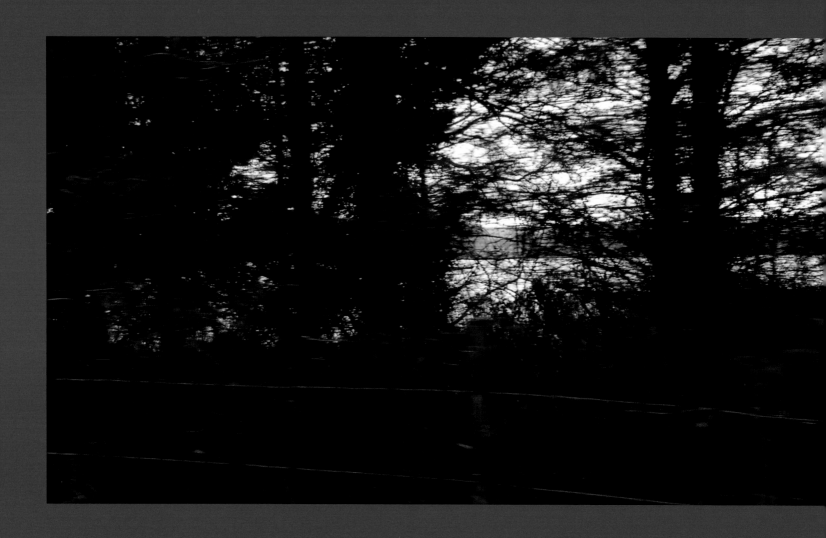

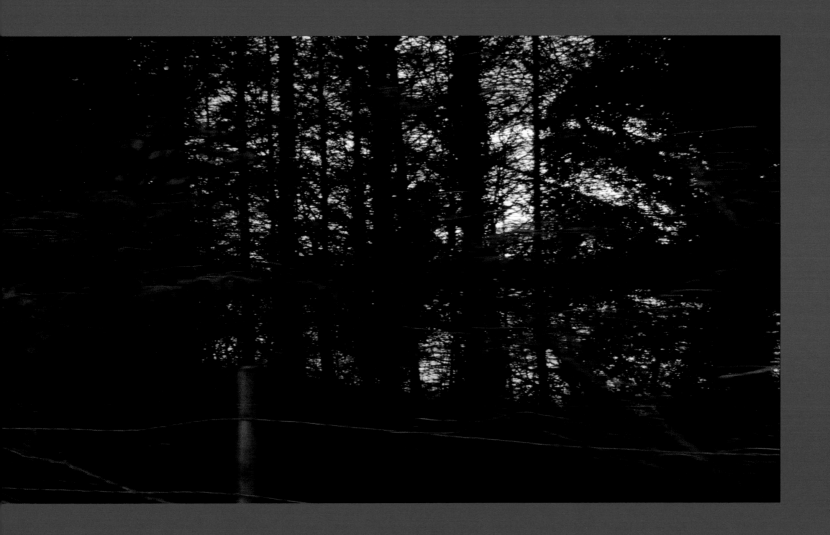

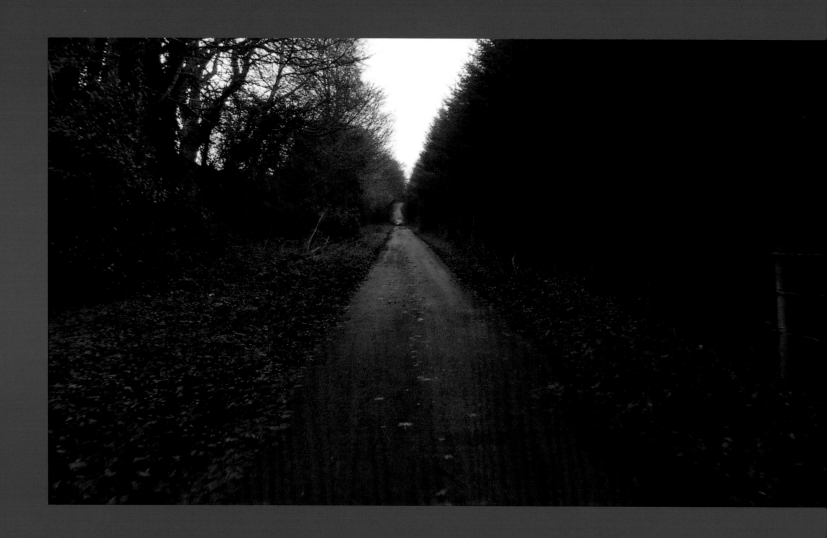

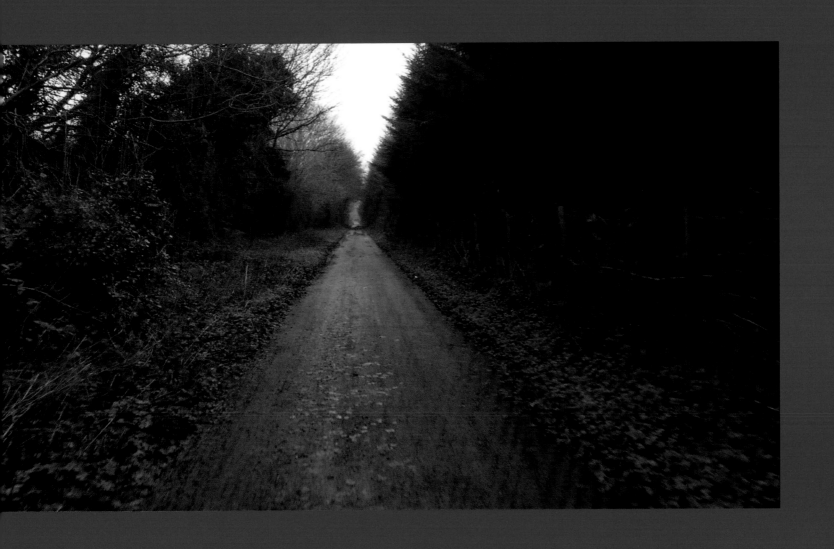

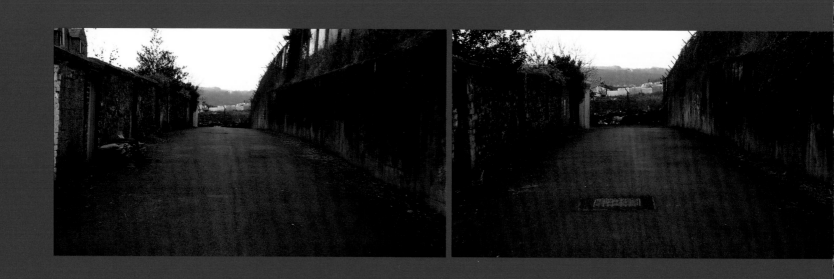

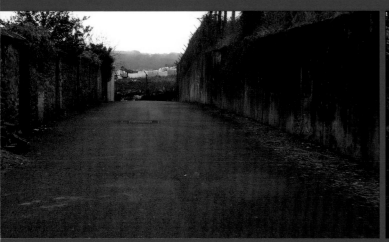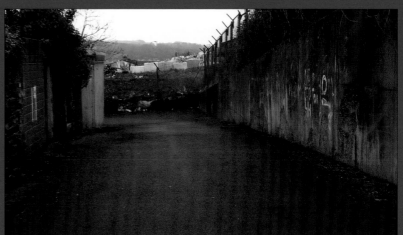

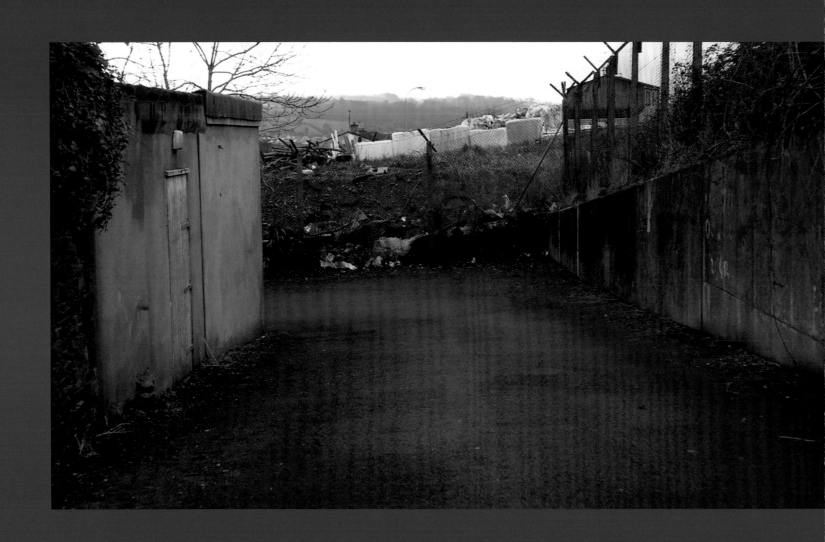

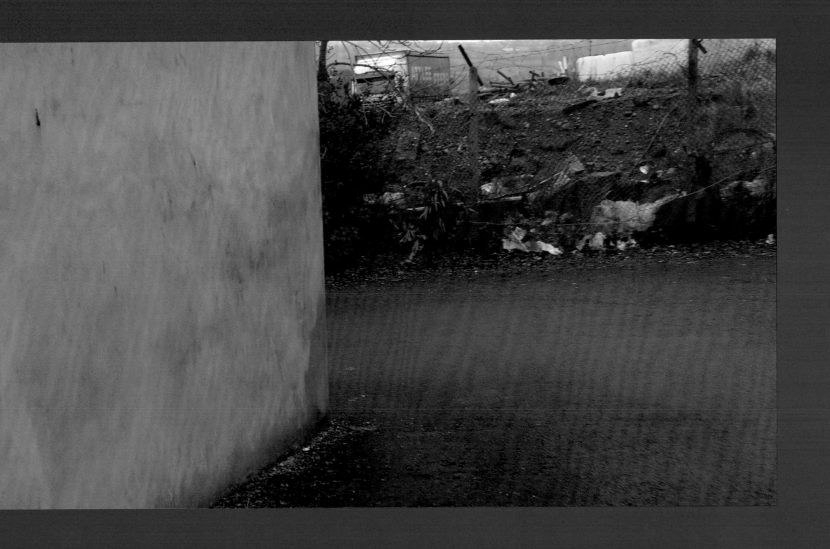

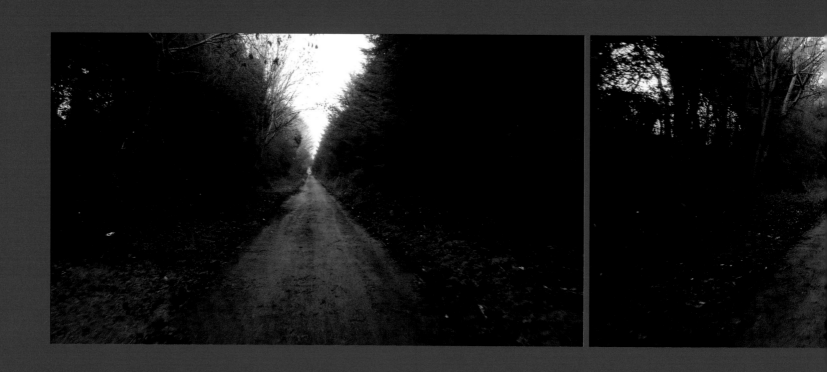

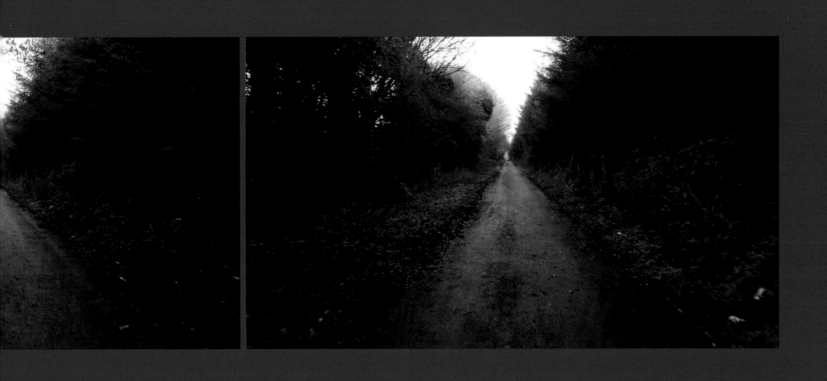

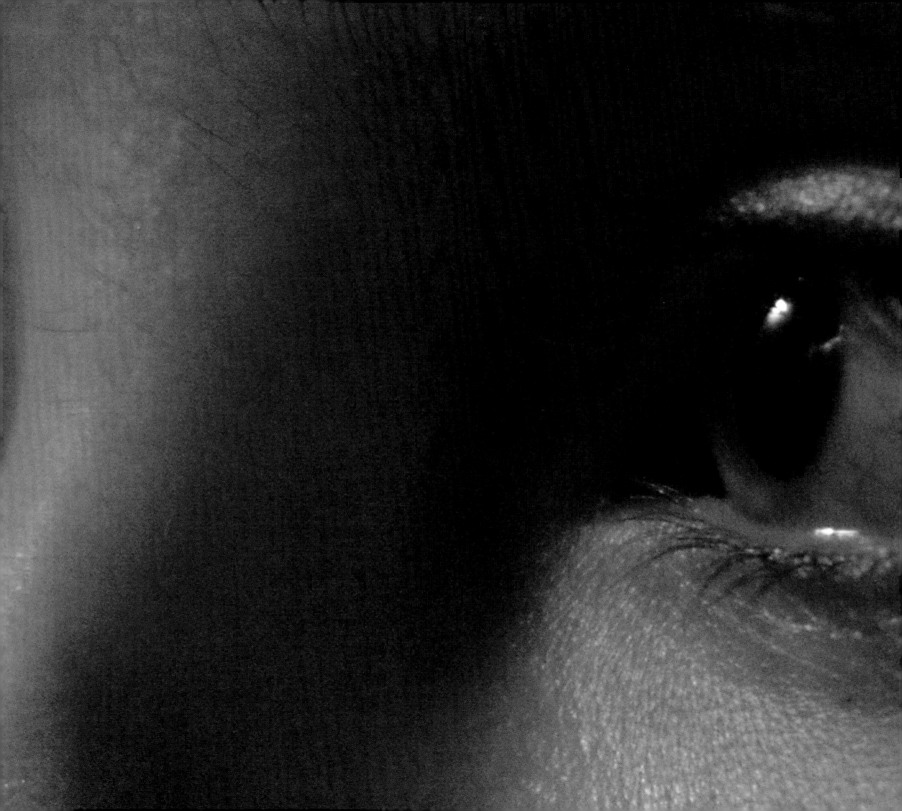

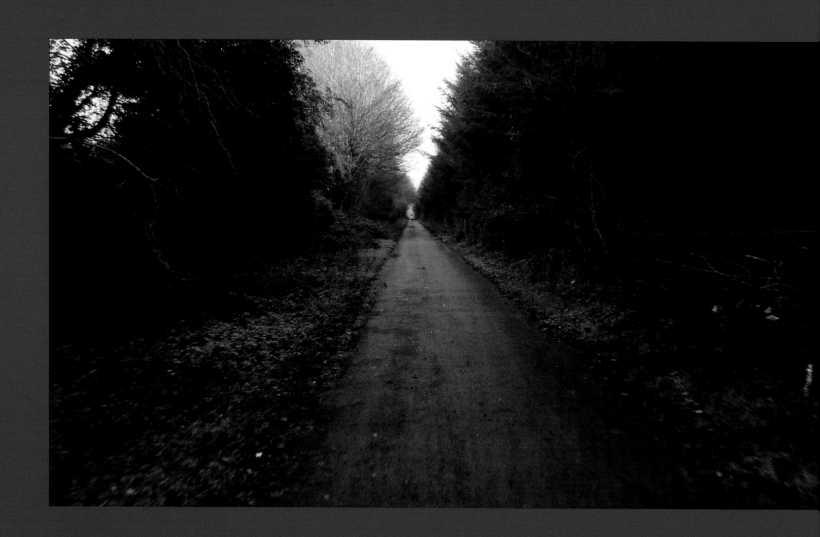

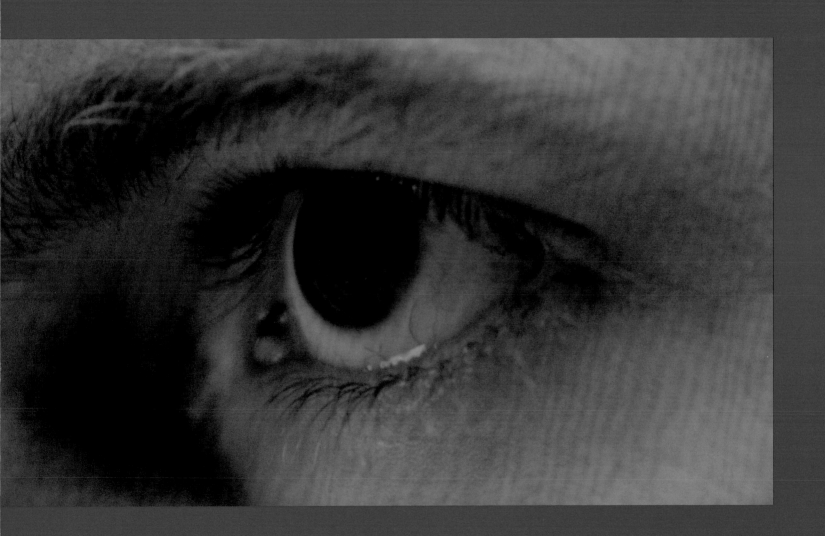

I found myself walking along a deserted path.

Through the trees on one side I could faintly make out a river in the distance.

On the other side I could hear the faint rumble of faraway traffic.

The scene was unfamiliar to me.

I looked over my shoulder and saw that the trees behind me were filled with shadowlike figures.

Looks of terror and bewilderment filled their eyes, and they silently screamed, as if already aware of their fate.

The scene reminded me of the faces in a running crowd that I had once seen on a bright but cold January afternoon.

Men and women slipped on icy puddles as they ran for safety.

A few, in their panic, ran towards a wire fence, further trapping themselves.

As they scaled the fence, a military vehicle drove through it, tossing them into the frosty air.

Troops spewed from the back of the vehicle as it screeched to a sudden halt.

They raised their rifles and fired indiscriminately into the fleeing

The next day, I walked over the waste ground that was now marked by deep tire tracks and footprints, fixed in low relief and highlighted by a sharp hoar frost.

I could find no other traces of the crowd.

I returned many times to the same site until another fence was erected and a new building was put in place of the empty, silent reminder.

I wondered about what had happened to the pain and terror that had taken place there.

Had it been absorbed or filtered into the ground, or was it possible for others to sense it as I did?

The narrow streets and alleyways that I walked along became places where this invisible matter could no longer be contained.

It seeped out through every crack and fissure in the worn pavements and crumbling walls.

Its substance became visible to me in the mossy, damp corners that never seemed to dry out in winter or summer.

A viscous secretion oozed from the hidden depths.

The smell of ancient mold mingled with the creeping odor of dead flesh.

The ground was often slippery underfoot, as if the surface of the road was no longer thick enough to conceal the contents of the tomb that lay beneath the whole city.

Some people claim that they are a malevolent presence, while others believe that they offer guidance and advice to their family and friends.

Not everyone can see them.

They inhabit a world somewhere between here and the next.

They move between the trees.

Caressing every branch.

Breathing, day and night, on every flickering leaf.

They are restless creatures whose intentions are often beyond our comprehension.

His body was discovered on an overcast Sunday morning.

I recognized him from the small black-and-white newspaper photograph that had accompanied the story of his murder.

He smiled reluctantly, self-conscious and timid when confronted by the lens.

As a boy, I stared at this photograph looking for a sign; unable to accept that the face was that of someone already dead.

I retraced my footsteps along paths and streets that I thought I had forgotten.

I walked past the place that I used to avoid and quickened my pace.

He was waiting for me, as I always feared he would, emerging from a scorched corner where broken glass sparkled on the blackened ground.

My train of thought was interrupted by a further incursion of unreality.

My eyes deceived me as I thought I saw a human figure.

No matter how quickly or slowly I walked, the figure did not seem to get any closer.

When I took my eye off the figure, it disappeared.

When I stared at the point where the path vanished, the figure emerged once again from the trees or from the path itself.

I could not tell.

I remembered shapes and colors from a flickering television screen.

The outline of a car silhouetted against a gray sky.

One door wide open, and the car skewed awkwardly into a shallow ditch.

A detail of the interior, gray checked fabric, an oily stain, a cassette player.

The number plate, three letters and four numbers.

The car had been abandoned and was partly burnt after a failed attempt to eliminate any forensic secrets that it might yield.

At first, I didn't see or hear the car.

It seemed to appear from nowhere.

In the evening twilight it was difficult to make out who was driving.

The car slowed down and waited for me to approach.

I became lost in memories of the minute details of photographs of people and places that I did not know.

Men being taken away blindfolded.

Their hands tightly bound by plastic cable ties.

Barking dogs. Cages.

Bodies in a pile. Guards standing over them smiling for the camera.

Stains on a white floor.

A car blown apart in a surgical strike.

A shoe and a newspaper lying on the dusty road.

The daylight wraith takes on the likeness of a living person.

The wraith is usually a vision of someone who is in another place at the time of the appearance.

It manifests itself during the hours of daylight in a place where the living person could not possibly be.

A wraith can assume the likeness of a close friend or relative or even appear as the viewer's own image.

The appearance of a friend or relative usually means that the person is already dead or in great danger.

To see one's own image is a warning of one's death within a year.

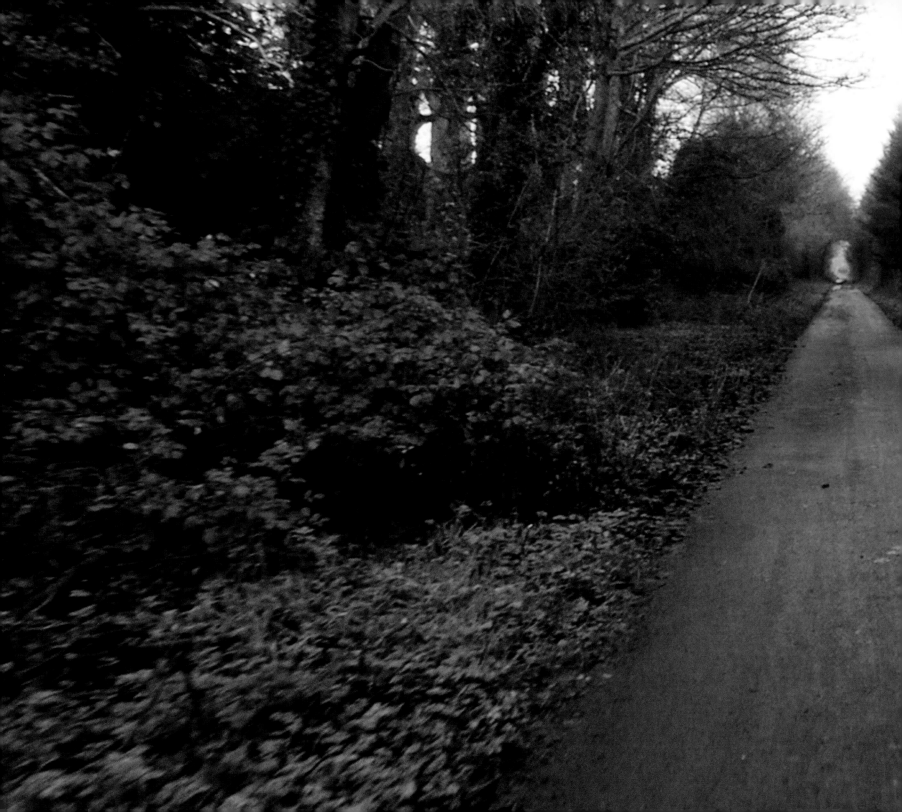

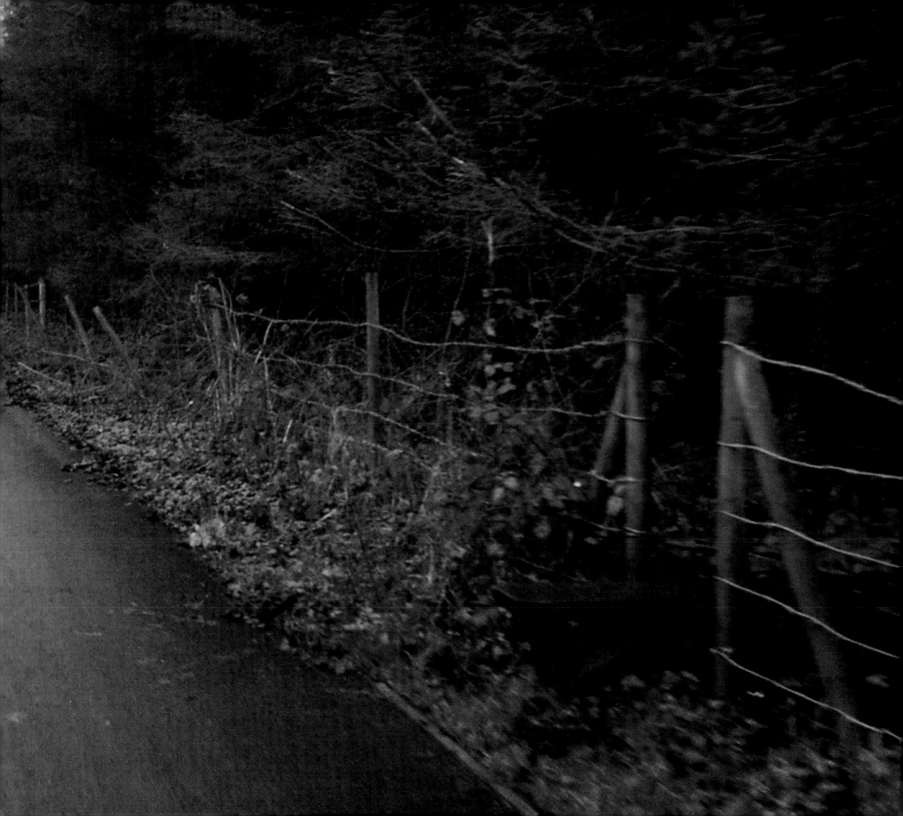

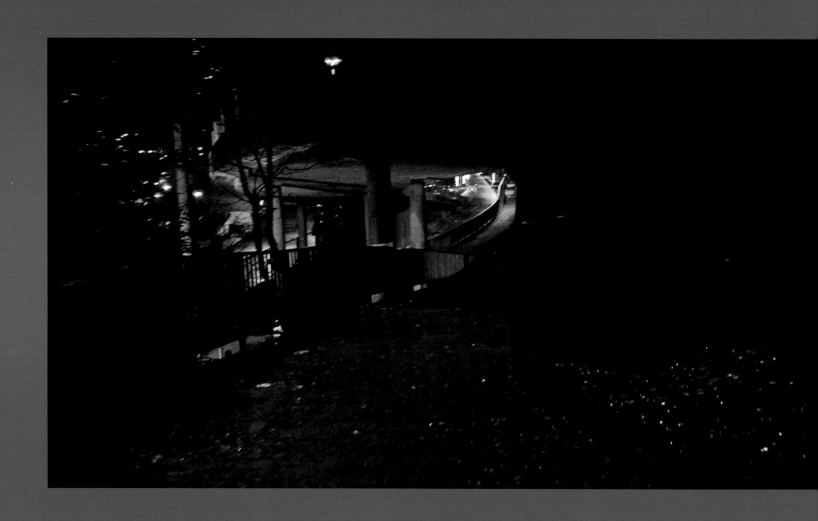

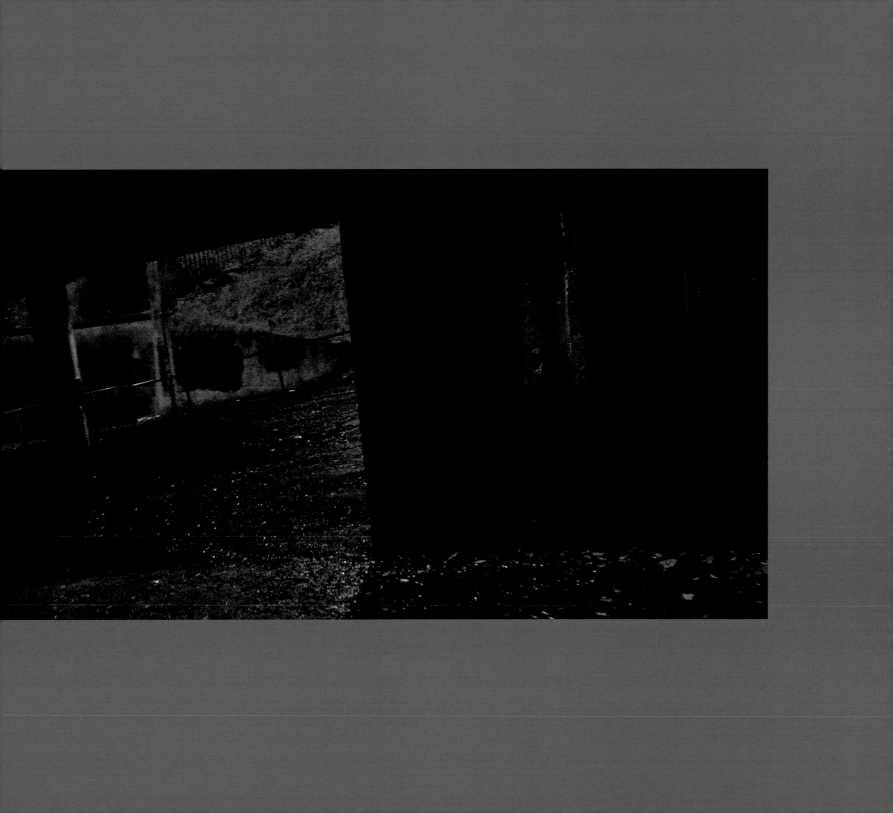

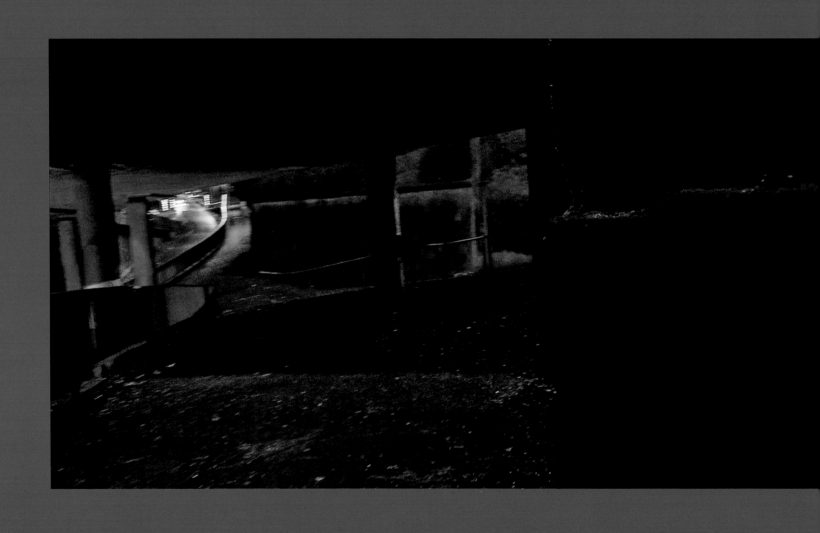

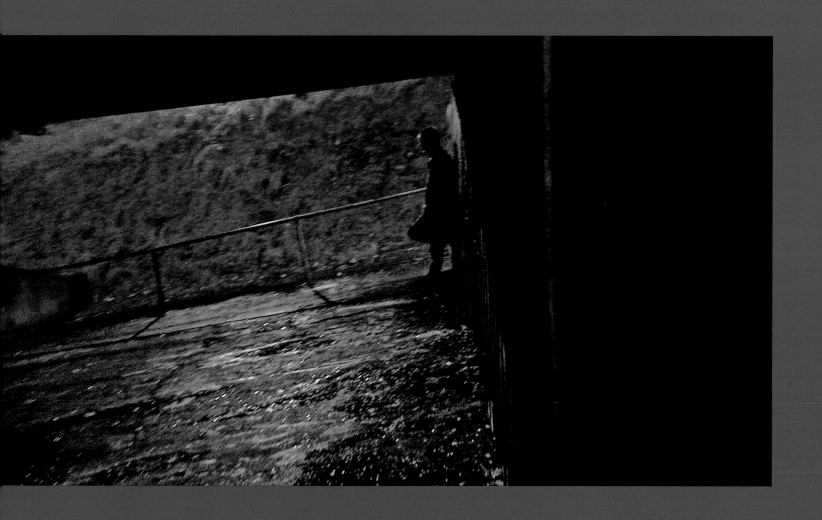

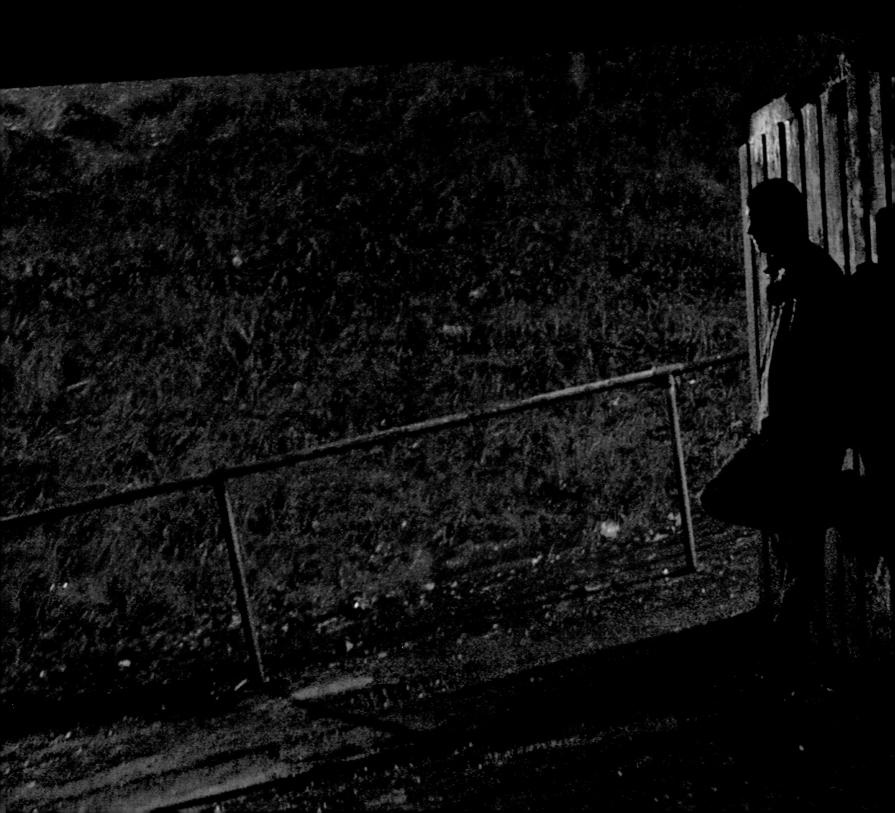

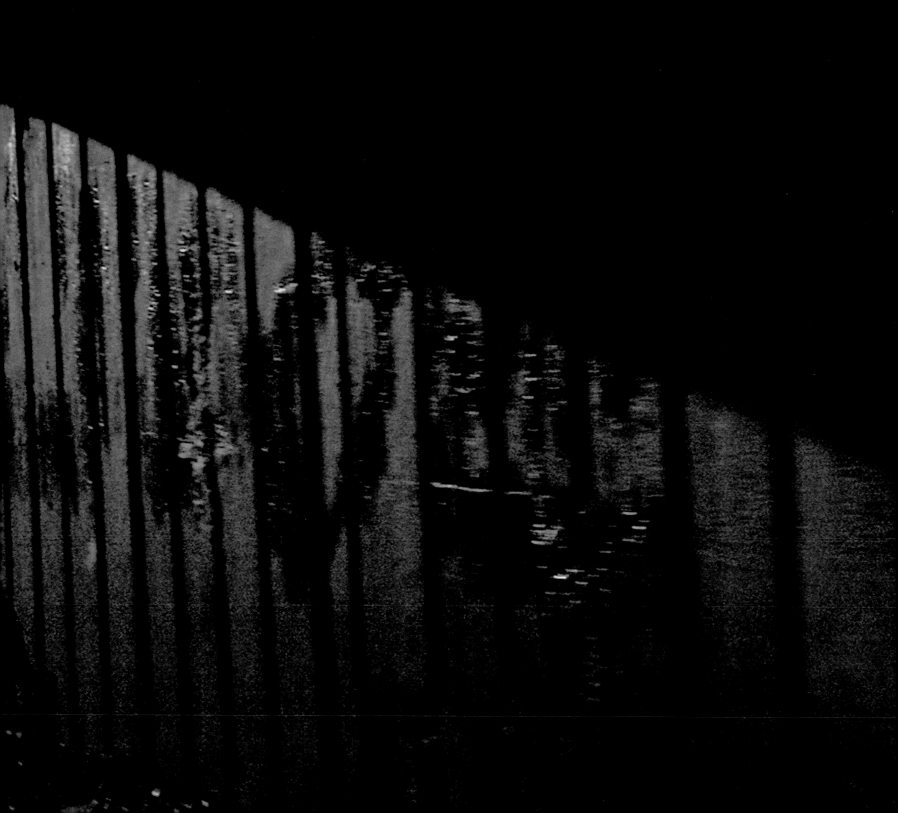

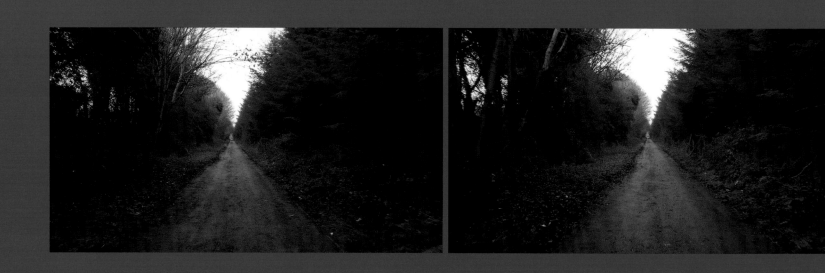

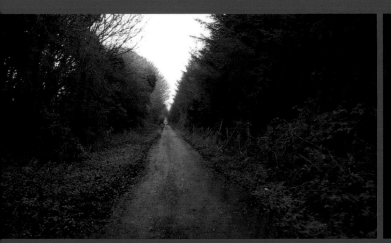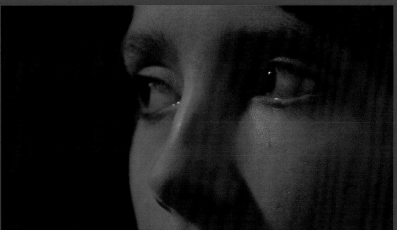

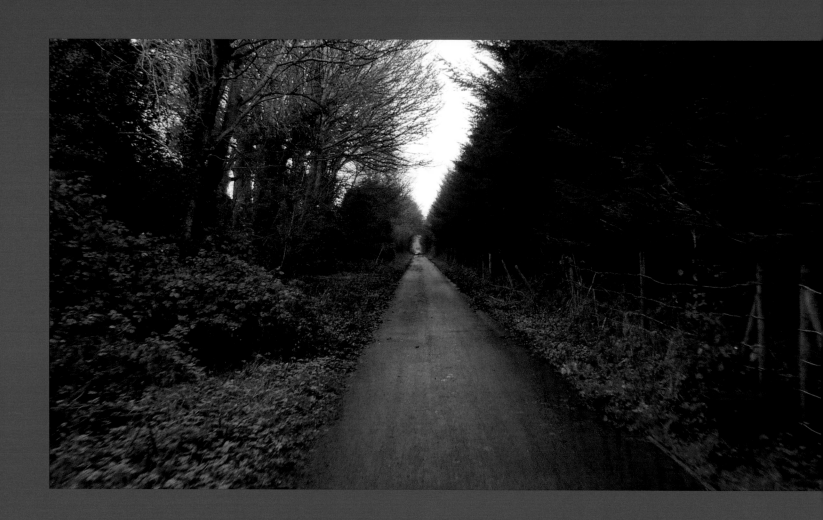

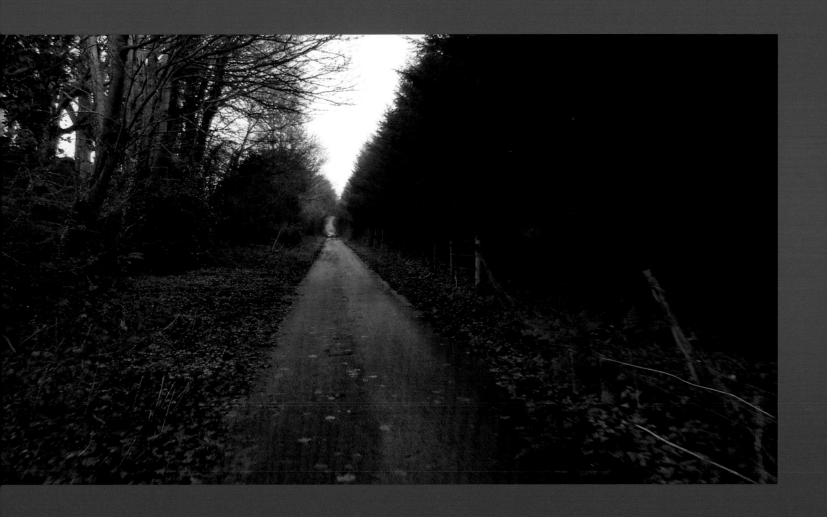

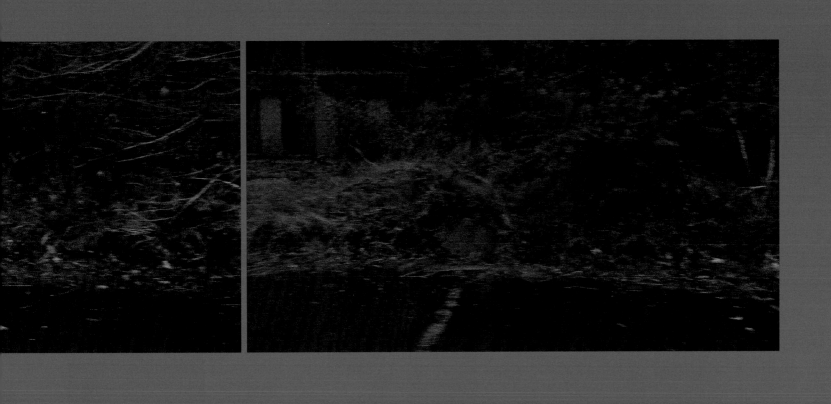

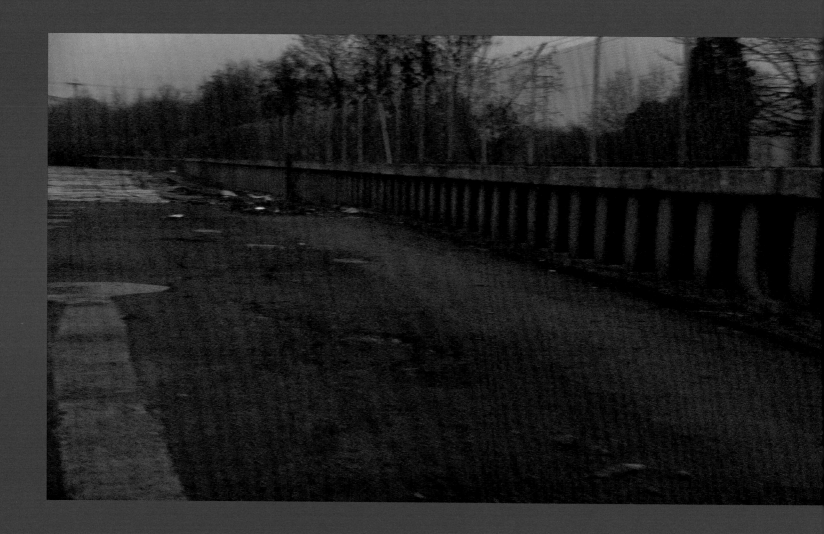

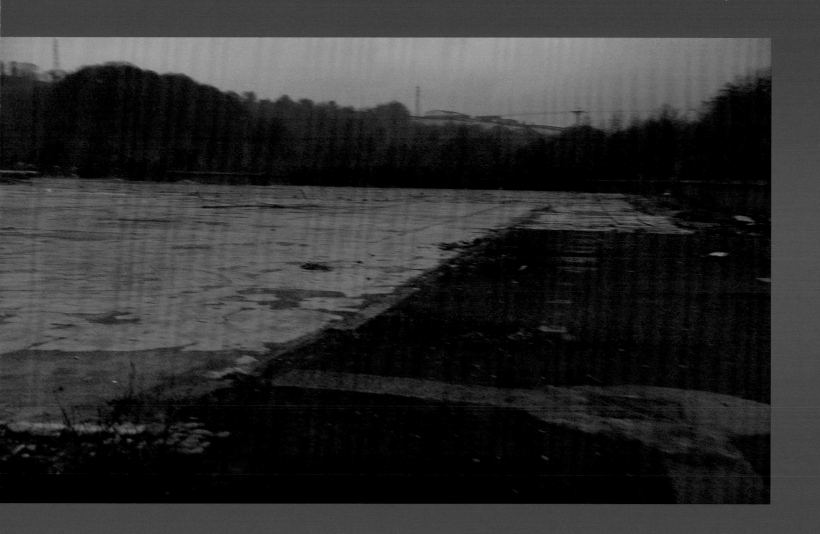

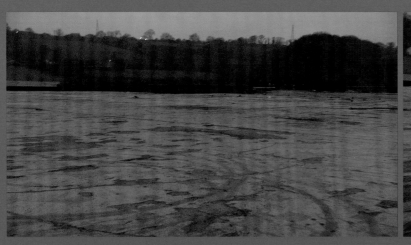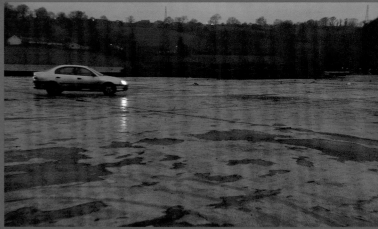

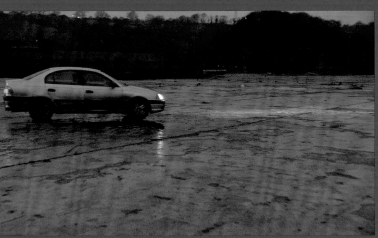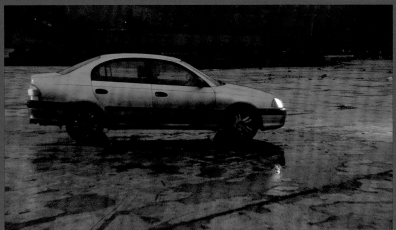

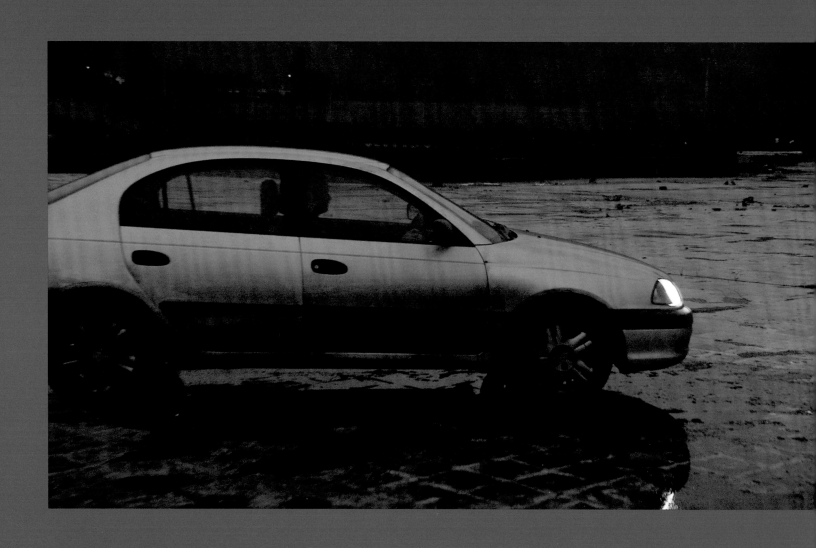

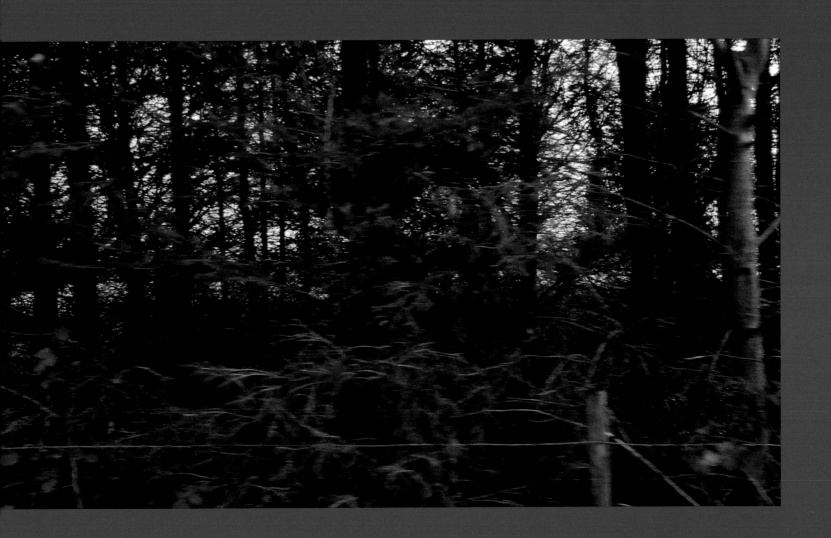

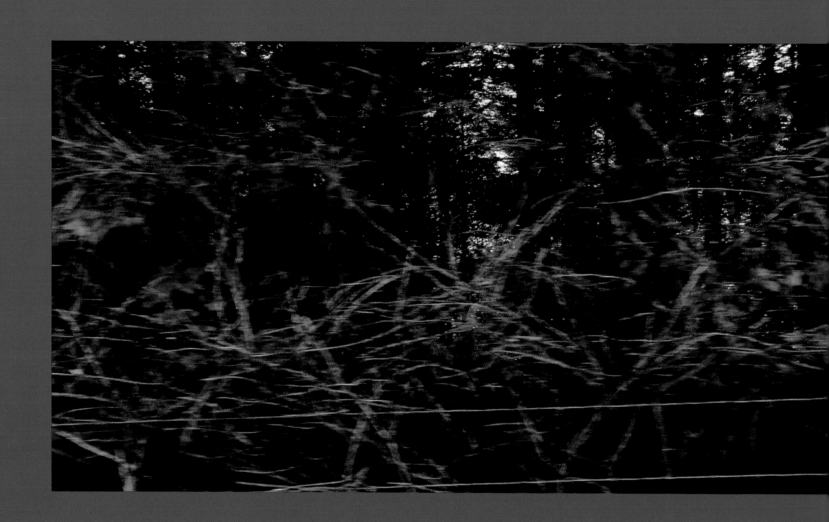

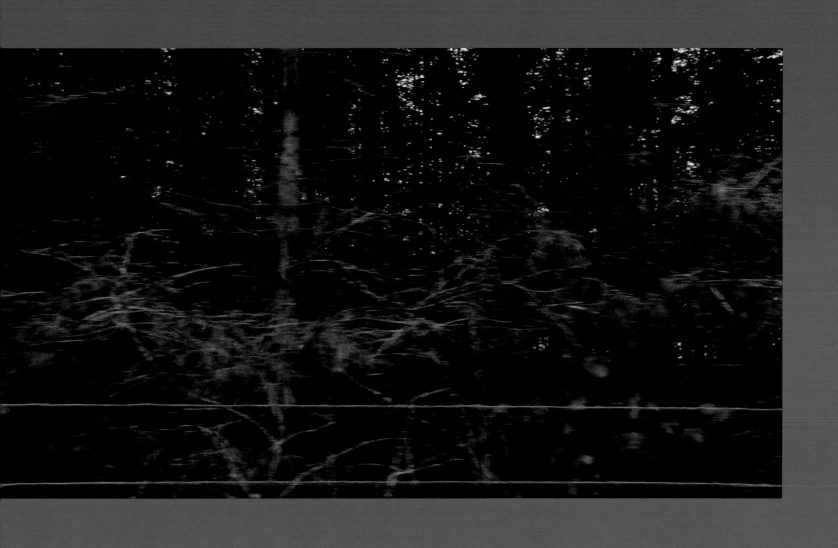

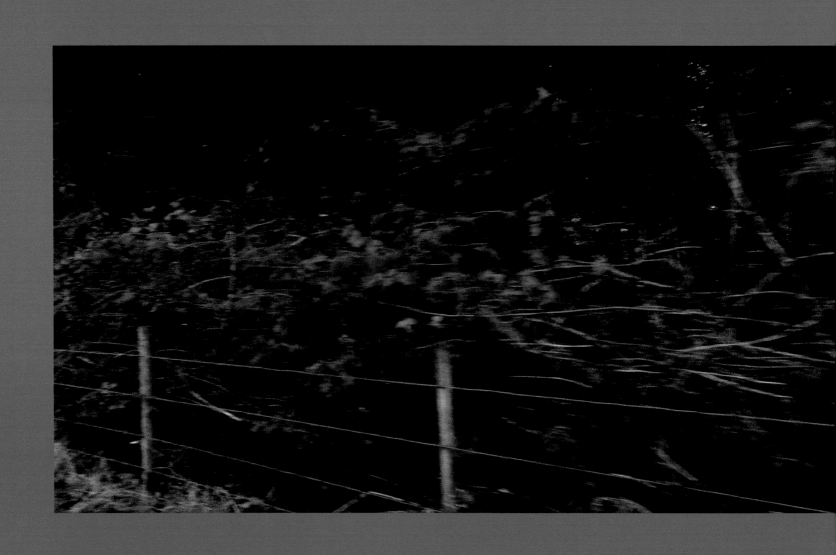

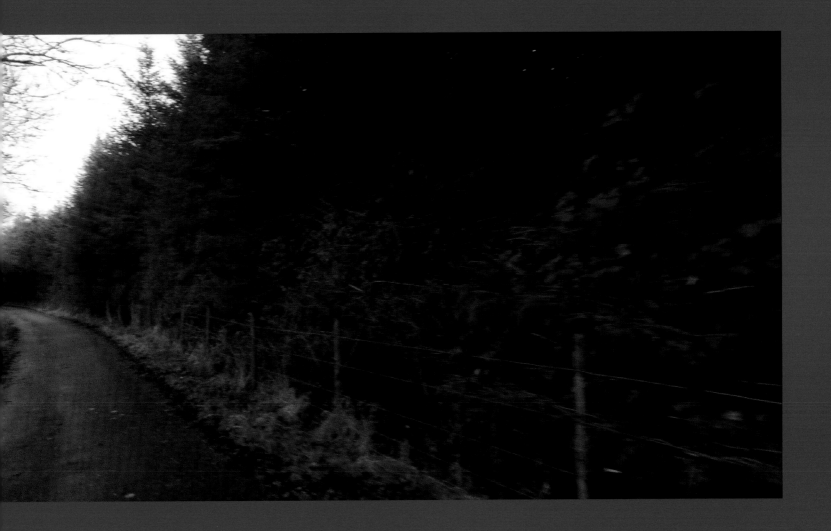

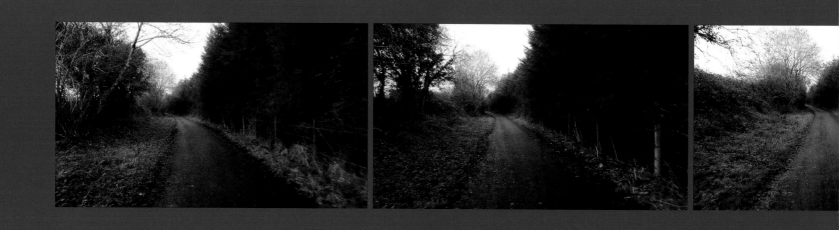

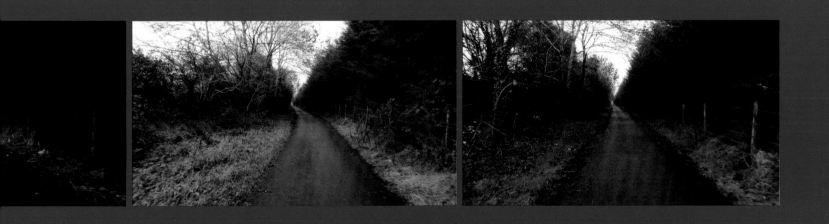

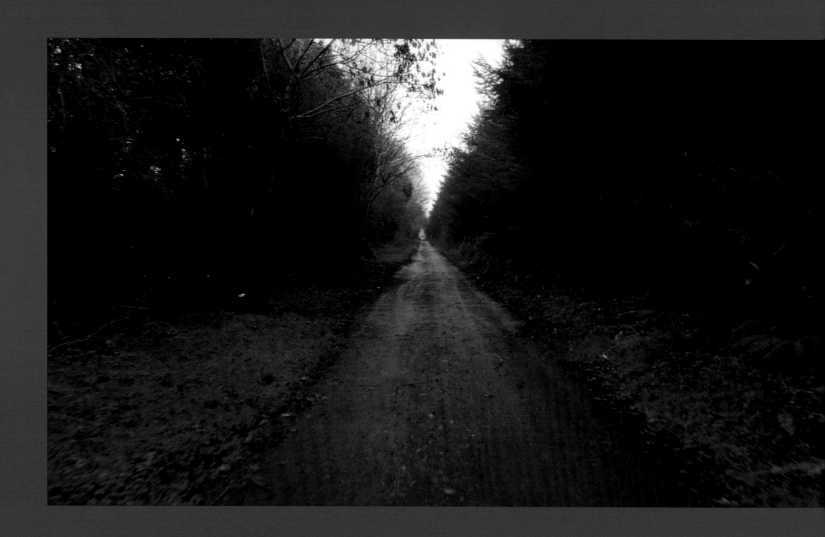

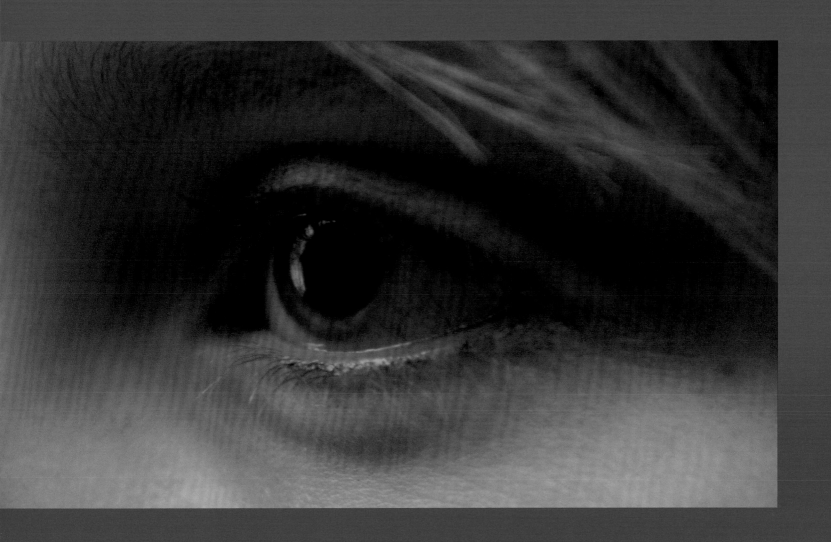

WILLIE DOHERTY—A BIOGRAPHY
ERIN K. MURPHY

In his work Willie Doherty highlights identity, truth, division, moral ambiguity, cinematic convention, and the perception of his viewers, themes he has consistently explored throughout his career. The nature of his early photography required at least a basic knowledge of Ireland's tumultuous history and a familiarity with the local vocabulary and journalistic and fictional sources specific to Northern Ireland. While remaining faithful to his personal history, Doherty expanded his use of black-and-white photography to embrace the potential of color in a search for work possessing the ability to transcend its subject matter. He wished to capture the complexities of political and social conflict, no matter the geographic location, and he called into question the media's propensity for judgment as expressed in its use of specific imagery and language. Continuing his investigation of language versus image, his early media work challenged the viewer to consider dual perspectives simultaneously rather than choosing, decisively, one or the other, and to engage in a dialogue with the work itself. Interaction with his works requires of us an active rather than a passive engagement, and the calculated arrangement of his installations within the gallery space contributes to the effect. In recent years, Doherty has maintained his inclination toward sociological inquiry and subjective interpretation while using conventions typical of cinema to evoke universal feelings of paranoia, suspicion, and instability.

Born in 1959 in Derry, Northern Ireland, Doherty spent his formative years amid the escalating sectarian and political violence known as the Troubles, which began in the late 1960s as civil rights demonstrations set off a succession of attacks and counterattacks between what became the entrenched positions of Unionist Protestants versus Nationalist Catholics. Doherty studied sculpture at Ulster Polytechnic in Belfast between 1978 and 1981. There he found it impossible to ignore the violence raging outside the institution, and his relationship to the history of Northern Ireland and the Republic of Ireland has served as one of the main backgrounds for his art. Returning to Derry in 1984, he searched for a way in which to address the ubiquitous conflict. His early work—black-and-white photographs of landscape overlaid with text—were first exhibited in the 1980s. His first media work, *Same Difference*, a slide piece, was produced in 1990 and exhibited at Matt's Gallery in London that same year. His first foray into video, *The Only Good One is a Dead One* (1993), was also exhibited at Matt's Gallery.

Since then, Doherty's photographic and media work has been displayed in numerous one-person exhibitions at institutions worldwide, among them, Kunsthalle Bern (1996), Art Gallery of Ontario, Toronto (1996), Tate Liverpool, in the U.K. (1998), the Renaissance Society, Chicago (1999), the Irish Museum of Modern Art, Dublin (2002), and Laboratorio Arte Alameda, Mexico City (2006). In 2007, an important one-person exhibition of Doherty's time-based work took place at the Kunstverein, Hamburg, and Städtische Galerie im Lenbachhaus und Kunstbau, in Munich, with an accompanying, comprehensive catalogue of his entire oeuvre of slide and film installations. He was short-listed for the Turner Prize in 1994 and 2003. His work has also been exhibited in major international exhibitions, including the Carnegie International (1999), the São Paulo Biennial (2002), and the Venice Biennale (2005). Most recently, he was chosen to represent Northern Ireland at the Venice Biennale in 2007. *Ghost Story*, the work that is part of the present exhibition, was first seen there. Deliberate and reflective, Doherty's evocative historical enquiry establishes him as one of the most powerfully affecting artistic voices of our time.

Photographs

1 INCIDENT, 1993
2 THE OUTSKIRTS, 1994
3 BORDER ROAD, 1994
4 AT THE BORDER III (TRYING TO FORGET THE PAST), 1995
5 UNAPPROVED ROAD II, 1995
6 AT THE BORDER I (WALKING TOWARDS A MILITARY CHECKPOINT), 1995
7 AT THE BORDER IV (THE INVISIBLE LINE), 1995
8 THE FENCE, 1996
9 NO VISIBLE SIGNS, 1997
10 BEHIND EVERY TREE, 1999
11 THE SIDE OF THE ROAD, 1999

Cibachrome on aluminum
Each: 48 × 72 in. (121.9 × 182.9 cm)
Exhibition copies

Video

12 GHOST STORY, 2007

Installation: one 16:9 video projector, one HD media player,
one stereo amplifier, two speakers
Minimum projection: 54⅛ × 94¼ in. (137.5 × 239.4 cm)
Duration: 15 minutes, looped
Edition 2 of 3
Dallas Museum of Art, DMA/amfAR Benefit Auction Fund, 2008.11

Library of Congress Cataloging-in-Publication Data

Wylie, Charles.
 Willie Doherty : requisite distance : ghost story and landscape / Charles Wylie ; with a contribution by Erin K. Murphy.
 p. cm.
 Published in conjunction with an exhibition organized by the Dallas Museum of Art, May 23–Aug. 16, 2009, and traveling to the Snite Museum of Art, University of Notre Dame, fall 2010.
 ISBN 978-0-300-15255-5 (alk. paper)
 1. Photography, Artistic–Exhibitions. 2. Landscape photography–Northern Ireland–Exhibitions. 3. Video art–Exhibitions. 4. Installations (Art)–Exhibitions. 5. Doherty, Willie–Exhibitions. I. Murphy, Erin K. II. Dallas Museum of Art. III. Title. IV. Title: Requisite distance. V. Title: Ghost story and landscape.
TR647.D637 2009
779'.36–dc22 2009002064

DALLAS MUSEUM OF ART

Bonnie Pitman, The Eugene McDermott Director
Charles Wylie, The Lupe Murchison Curator of Contemporary Art
Erin K. Murphy, Curatorial Administrative Assistant, Contemporary and Decorative Art
Tamara Wootton-Bonner, Director of Exhibitions and Publications
Eric Zeidler, Publications Coordinator
Nico Machida, McDermott Curatorial Intern
Caitlin Overton, McDermott Curatorial Intern

Distributed by Yale University Press, New Haven and London
 www.yalebooks.com

Cover: Still from *Ghost Story* by Willie Doherty (2007)
Pages 2, 4, and 38: Stills from *Ghost Story* by Willie Doherty (2007)

Edited by Frances Bowles
Proofread by Sharon Rose Vonasch
Designed by Jeff Wincapaw
Typeset by Brynn Warriner in Eidetic Neo
Color management by iocolor, Seattle
Produced by Marquand Books, Inc., Seattle
 www.marquand.com
Printed and bound in China by Asia Pacific Offset